Painting with
Brenda Harris

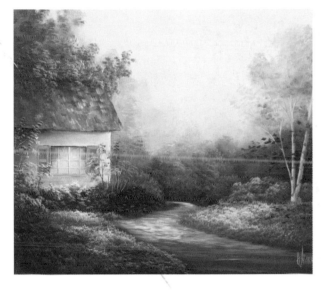

VOLUME 3:
LOVELY LANDSCAPES

NORTH LIGHT BOOKS
CINCINNATI, OHIO
www.artistsnetwork.com

Brenda Harris started painting as a hobby at the age of thirty-one. A few years later, encouraged by her family and friends, she entered her first juried art show. Her style and ability to capture one's imagination proved to be a winning combination; she was awarded high honors in the show. She continued to exhibit, winning numerous awards. However, it was not until Brenda started sharing her techniques with others that her true talent emerged: teaching.

Armed with boundless energy, unlimited patience and a love for painting, she began teaching workshops for a small group of friends in Jacksonville, Florida. From these small but enthusiastic workshops, Brenda has become an instructor of national television acclaim.

Since 1987, Brenda has taught thousands of students via public television, filming more than 180 educational shows. In addition, she has written more than a dozen instructional books. Her books, classroom persona and paintings reflect her true attention to detail and joy in sharing.

Although Brenda's schedule is demanding, her favorite times are those spent sharing and teaching in small paint-along workshops. She believes that nothing replaces the one-on-one personal touch.

For more information about Painting With Brenda Harris *seminars, books, lesson plans, instructional videos and painting supplies, contact:*

Painting With Brenda Harris
P.O. Box 350155
Jacksonville, FL 32235
Phone: (904) 641-1122
Fax: (904) 645-6884
brenda@brendaharris.com
www.brendaharris.com

About the Author

Painting With Brenda Harris, Volume 3: Lovely Landscapes. Copyright © 2006 by Brenda Harris. Printed in Singapore. All rights reserved. No part of this book may be reproduced in any form or by any electronic or mechanical means including information storage and retrieval systems without permission in writing from the publisher, except by a reviewer who may quote brief passages in a review. Published by North Light Books, an imprint of F+W Publications, Inc., 4700 East Galbraith Road, Cincinnati, Ohio 45236. (800) 289-0963. First Edition.

Other fine North Light Books are available from your local bookstore, art supply store or direct from the publisher.

10 09 08 07 06 5 4 3 2 1

Library of Congress Cataloging in Publication Data
Harris, Brenda.
 Painting with Brenda Harris. Volume 3, lovely landscapes / Brenda Harris.-- 1st ed.
 p. cm.
 Includes index.
 ISBN-13: 978-1-58180-739-4
 ISBN-10: 1-58180-739-2
 1. Landscape painting--Technique. I. Title: Lovely landscapes. II. Title.
 ND1342.H374 2006
 751.45'436--dc22

 2005034969

Edited by Erin Nevius
Art direction by Wendy Dunning
Cover designed by Nicole Armstrong
Interior layout by Dan Phillips
Production coordinated by Mark Griffin

Metric Conversion Chart

To convert	to	multiply by
Inches	Centimeters	2.54
Centimeters	Inches	0.4
Feet	Centimeters	30.5
Centimeters	Feet	0.03
Ounces	Grams	28.6
Grams	Ounces	0.035

Distributed in Canada by Fraser Direct
100 Armstrong Avenue
Georgetown, ON, Canada L7G 5S4
Tel: (905) 877-4411

Distributed in the U.K. and Europe by David & Charles
Brunel House, Newton Abbot, Devon, TQ12 4PU, England
Tel: (+44) 1626 323200, Fax: (+44) 1626 323319
Email: mail@davidandcharles.co.uk

Distributed in Australia by Capricorn Link
P.O. Box 704, S. Windsor NSW, 2756 Australia
Tel: (02) 4577-3555

Dedication

I dedicate this book to YOU, dear students and painting buddies. Without your appreciation of my work and confidence in me to buy this book and my previous books, I would be without a job as an author and teacher! It is your encouragement that keeps me going.

Teaching and sharing my painting techniques has been a godsend to my life. It has provided me with more friends than anything I have ever encountered. All of you are jewels in my life's treasure box. You are like an extended family to me. Thanks for being there.

Palm Trees in Paradise
16" x 20" (40cm x 50cm)

Acknowledgments

It is very difficult to acknowledge all those who have contributed to the making of my books. So I acknowledge, up front, that my books are a collaboration by individuals too numerous to list. I could never accomplish something like this on my own.

First of all, I would like to acknowledge my husband Roger Harris, who picks up the slack for me when I spend unbelievable amounts of hours painting, re-painting, writing, re-writing, proofing and re-proofing. He manages my Web site orders and mail correspondence, he cooks, cleans, does the laundry and takes care of me and the family during these demanding times without the slightest bit of resentment or hesitation. Although I forgot to mention it, Roger was even the photographer for my first two North Light Books: *Painting With Brenda Harris, Volume 1: Cherished Moments* and *Painting With Brenda Harris, Volume 2: Precious Times.*

Secondly, I would like to acknowledge my dear friend and mentor Este Rayle, who has been a tremendous help during the creation of this book. Since I met Este twenty years or so ago, she has been like a beacon in a storm, guiding me and keeping me on track. She remains on an even keel no matter how rough the water. Este's organizational skills are enviable. She has the ability to take a chore and turn it into a fun experience. Seemingly, she never tires: Este is like the pink bunny from the commercials, she keeps on going … and going … and going! I haven't space enough to tell all the amazing aspects of Este or to list all the many ways she has positively impacted my life and work. So I will conclude by saying she is as exemplary as a person as she is as an artist, top notch!

I tip my hat to Erin Nevius for all of her efforts in making this book possible. Many of the ideas within these pages are hers, as well as her selection of paintings to be featured!

Erin typed copious notes while I was repeating the paintings at the photo shoot, providing me a strong base to start from when writing the step by steps. She also rearranged and edited my writing, making it sound professionally done. She did a phenomenal job.

And, of course, what would a book be without great photographs? For that, I have to acknowledge the talented Christine Polomsky. What a joy it was to paint in front of her camera. Christine's cheerful personality, encouraging words and hearty laugh were as uplifting as sunshine on a rainy day. She kept us smiling and did a great job of shooting all these photos, as well as handling other tasks around the studio at the same time. Instead of making it an arduous task, she made the photo shoot a joyful experience. Good job, Christine!

And to all the staff at North Light Books and F+W Publications, I acknowledge your professionalism. I am in awe of how and what you do.

Table of Contents

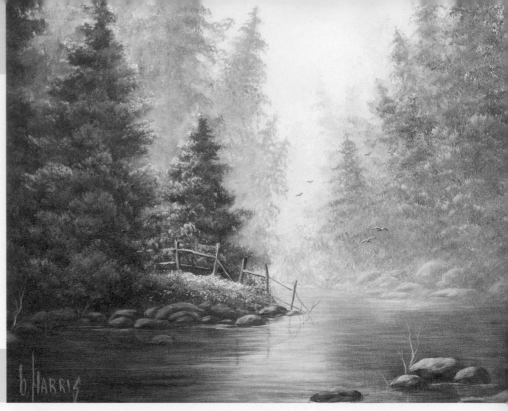

Lazy River
16" x 20" (41cm x 51cm)

Introduction

As with everything we have learned in life, learning to paint is a step-by-step process. The more you practice the faster you will learn and the easier it becomes.

Everyone does their best work when they are in a good frame of mind, so always try to maintain positive thoughts. You will face trying times, peaks and valleys, along your artistic learning journey. There will be times when you will focus on negative thoughts such as "this is not easy for me," "I can't do this," "my painting doesn't look like it should," "I'm not talented," or similar discouraging thoughts.

For those times, I'd like to share with you my favorite word, a word that keeps me going: "yet." When I am inclined to think something is not easy, I add "yet" to the end of

that thought, knowing it's just a matter of time and practice before it becomes easy. Adding "yet" to the end of a negative thought opens your mind and gives you the hope and encouragement you need to continue, readying you to achieve your goal of becoming a talented artist.

No one has ever been born an artist—we are born knowing only how to eat. Other than that, we learn to do all the things we do. We even learn and accomplish a completely different method of eating. Our quickest method of learning is to imitate the actions of those around us. Whether you decide to become an artist when you are young or old, you have to learn techniques and develop skills that will enable you to create the artwork of your choice.

My definition of talent is the God-given ability, willingness and eagerness to learn a particular thing. Talent means having learned and developed the skills needed to perform your chosen task. So, unless you have been painting for some time, you may not have developed your artistic talents to their fullest … yet. You may not be artistically talented … yet. But with desire and eagerness to learn, you will be! The sooner you get started painting, the sooner you will develop as an artist. Even if you've never painted a single thing in your life, you can become a very successful and talented artist!

Brenda's Basic Techniques

Throughout this book you will work with patterns (pages 100–109) that you will transfer to the canvas for each painting. In some projects you will also use design protectors and mats. This page explains these three techniques.

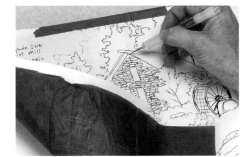

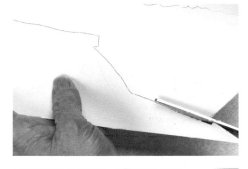

Using an Adhesive Design Protector

When you paint the background first, you'll often need to protect an area of your painting. Trace the outline of the area you need to protect onto a piece of label paper or any type of adhesive-backed paper (found at office supply stores) using the same technique as transferring a pattern. Cut out the image, remove the backing, align the design protector over the traced image and press it onto the dry canvas.

Paint carefully around the protector. Whenever possible, start with the brush on the protector and stroke away from it, because stroking toward the design protector may force paint under it. When you're ready to paint the image under the protector, carefully peel it off the canvas.

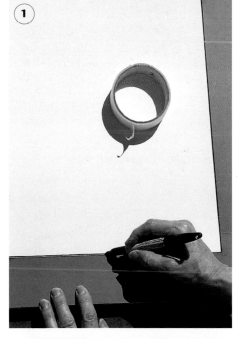

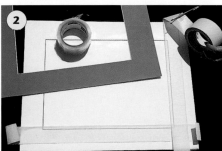

Transferring a Pattern

Enlarge the pattern according to the percentage indicated. Lay the canvas on a flat, sturdy surface and tape the pattern firmly in place. Insert a piece of white or black transfer paper, powdery side down, between the pattern and the canvas. Trace the lines with a stylus or a ballpoint pen without any ink in it. While the pattern is still taped in place, lift a corner to check for missed lines.

Remove any visible transfer lines with a kneaded eraser or a clean, moist sponge after the painting has dried.

French Matting

(1) Place the canvas on a flat surface, then place the mat template (precut photograph matting that can be purchased from any craft or framing store) over it. Hold the mat template securely and trace the inside edges with a waterproof permanent marker or technical pen. (2) Remove the template and let the ink dry. Cover the border with masking or shipping tape, overlapping the tape about ½ inch (12mm) inside the ink lines on all four sides. (3) After the painting is finished, remove the tape to reveal an unpainted border around your painting.

If you would like to create the appearance of double matting, you can use two templates, one with a slightly larger opening. To prevent color seepage under the tape while painting, seal it by applying Clearblend over the inside edges of the tape, fading toward the center of the canvas.

Acrylic Paint and Mediums

Acrylic Paint

You can paint with with acrylic tube colors or bottled acrylics. All brands of acrylic paint dry at about the same rate and can be mixed and cleaned up with water. Use cool, clean water when mixing, painting or cleaning; never use oils, thinners or turpentine with acrylics. If you want to slow the drying time, add Slowblend or a retardant medium to the water in your water container.

Select a brand that is easily accessible and affordable for you. You can set up your palette with colors from several different brands and combine bottled and tube acrylics on the same palette. Most of the colors will not be applied purely from the tube; instead, they will be tinted with white or toned by mixing with other colors.

When applied, acrylics dry at an uneven rate. Often the outer edges of an application begin to dry first; this can cause a spotty appearance. Usually, the color will even out and darken when it is completely dry. Speed the drying process with a hair dryer held a few inches away from the canvas. Use a low temperature and keep moving the dryer around the canvas.

Mediums

For the projects in this book, I have used three types of acrylic mediums which let you create beautiful color blends. There are a lot of different acrylic mediums besides these three—ask your paint supplier for recommendations, or contact me (brenda@ brendaharris.com) to purchase these directly.

Whiteblend® is excellent for painting wet-into-wet and creating soft, subtle colors. Acrylic paint dries slower and blends better when mixed with it. It can be used as white acrylic paint, or you can mix it with tube acrylic colors to tint them. Unless otherwise noted, all colors or mixtures in this book should have water or a medium added to them and be mixed to the same consistency as Whiteblend.

Clearblend® adds transparency to colors and dries flexible and water-resistant. It appears white in use but dries clear; it also is permanent when dry. Use it to create soft edges, transparent glazes and gradual blends and washes. It dries at the same rate as Whiteblend and can also be used in a wet-into-wet wash where you do not want to tint or lighten the colors.

Slowblend® is a clear, slow-drying medium. It dries flexible but less water resistant than Whiteblend or Clearblend. When applying paint to the canvas, Slowblend is used primarily to slow the drying time in the final layers and details. I add about a ½ teaspoon per cup of water in my water container as I paint to slow the drying. In arid locations, I double the ratio. Mix no more than one part Slowblend to two parts paint; too much Slowblend can compromise the paint binder, which causes paint to lift easily from the canvas. Heavy use of Slowblend is not recommended when subsequent layers of paint are to be added.

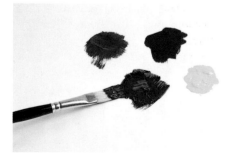

Acrylic Colors

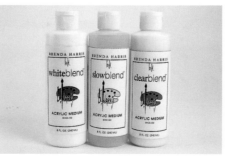

Mediums

Using a Palette and Mixing Colors

I use the Masterson Sta-Wet Super Pro palette system. It consists of a sponge sheet, special stay-wet palette paper and a durable storage container with a lid. Once you moisten the sponge sheet and paper and lay the palette paper over the wet sponge, you'll be ready to add colors.

Mixed color Marbleized color mixture

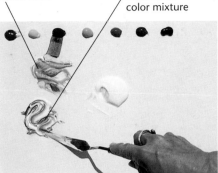

Mixing Colors Using Your Palette

I have listed color mixtures in every project in this book. You should mix these before you begin to paint. Mixing colors is an art, not a science! Squeeze out a marble-size dollop of each tube pigment along the edge of your palette paper. Use a clean, tapered painting knife to pull out a small amount (about the size of a pea) of your main color. Add other colors in lesser amounts and mix to the tint or shade you want. I prefer to leave the mixture slightly marbleized. This gives a mottled, slightly streaky appearance, which adds interest to paintings. It's up to you to decide exact hues; there are no precise formulas. Often it's best to mix colors directly on the brush or sponge This is referred to as "brush-mixing." Brush-mixing is useful when only a small amount is needed or when a gradual change of value or color is desired, such as when you add highlights.

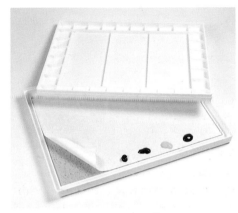

Adding Paints to Your Palette

Place paints on the palette paper to mix your colors. The paint will stay workable as long as the sponge pad and paper remain wet. As the pad dries around the edges, the paper will curl. When this happens, lift up a corner of the paper, add water to the dry areas of the sponge pad and press the paper back in place, moistening it.

To store the mixed paint on your palette, carefully lift the paper off the sponge and lay it to one side. Remove the sponge and squeeze out the water. Replace the sponge, then place the paper with the paint back on the sponge. Place the lid on the tray. Your paints will remain the same for several days. If you plan to save the paint longer and want to avoid a musty odor when you open the box, place the tray in the refrigerator.

Brenda's Palette

I use mostly student-grade acrylics. However, I have to buy some colors in professional grade because they are not available in student grade. Different brands may use different names for the same color. I have listed acceptable substitutes or the different names in parentheses.

Acrylic Colors

Burnt Sienna
Burnt Umber
Cadmium Red Light (Monoazo Orange)
Cadmium Red Medium
 (Grumbacher Red)
Cadmium Yellow Medium
 (Diarylide Yellow)
Cerulean Blue
Dioxazine Purple
Hooker's Green (Sap Green)
Magenta
Mars Black
Payne's Gray
Phthalo (Thalo) Blue
Phthalo (Thalo) Crimson
 (Acra Magenta/Violet or Thio Violet)
Phthalo (Thalo) Green
Phthalo (Thalo) Yellow Green
 (Vivid Lime Green)
Raw Sienna
Titanium White
Ultramarine Blue
Yellow Ochre (Yellow Oxide)

Mediums

Clearblend
Slowblend
Whiteblend

Working With Your Brushes

For brushstrokes and techniques there are many terms that often mean different things to different artists. Following are the terms used in this book and definitions of corresponding techniques.

Loading a Brush

Have a large container of clean water (with a ½ teaspoon of Slowblend added per cup of water) handy to moisten your brushes before using them. Squeeze the bristles to remove excess water from large brushes; tap smaller brushes on a clean towel. To get a smooth application, load the brush from side to side. Moisten your brushes frequently while painting to ensure smooth, even coverage.

Double Loading

Apply two colors to the brush at one time. Load the brush with the darkest color of the subject, then pull one side of the brush through the highlight color to create a dark and a light side. Position the brush so the stroke is half dark and half light as you move along the canvas. This technique saves time when creating delicate details such as birds or tree limbs.

Side Loading

Load your brush with medium or water, then blot the excess on a paper towel. Dip one corner of the brush into your paint. Gently stroke the brush back and forth to create a gradation between the paint and water or medium. This should produce a graded color from bold at one end to neutral at the other. You can also side-load your brush using white and a color or using two colors.

Loading a Brush

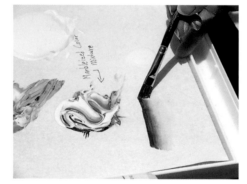

Side Loading

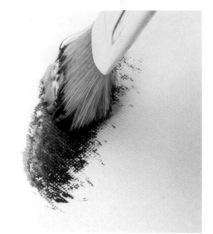

Crunching

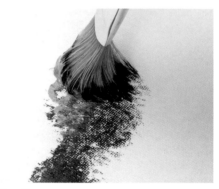

Stippling

Double Loading

Crunching

Hold the brush perpendicular to the canvas and press the tip of the brush against the canvas. Holding the brush in place, push slightly upward to bend the tips of the bristles downward and their centers upward, causing the bristles to flare out.

Stippling

Flare the brush before and during loading. Hold the brush perpendicular to the canvas and bounce in the paint, causing the brush to flare open. Tap it against the canvas to apply random, tiny specks of paint.

Tapping and Patting

Angle the brush toward the canvas. Using less pressure than for crunching or stippling, lightly tap a small part of the brush tip on the canvas.

Correcting Mistakes

Don't be afraid of making mistakes; we all do. Anything you put on your canvas can be corrected. Remove wet mistakes using a clean, damp sponge, paper towel or brush. If an error is stubborn to remove, gently agitate it with a toothbrush moistened with Slowblend, then wipe it away. If your mistake has dried, paint over it using Clearblend and the wet-into-wet technique described below. Or, would it be easier to simply cover it with foliage or a cloud? Train yourself to think creatively!

Wet-Into-Wet

Paint a base color or Clearblend directly onto the canvas, then apply one or more colors directly onto it. Blend the colors together quickly before they dry.

Wet-Next-to-Wet

Apply two acrylic colors next to each other, slightly overlapping them. Blend them together where they overlap. This creates a gradual transition between the colors.

Wet-on-Dry

Apply and blend wet acrylic paint over dry acrylic paint. If the color or blend does not suit you, you can remove the wet color with a moist towel or sponge and try again without losing anything.

Wet-on-Sticky=Extremely Tricky

Avoid applying or blending wet paint in and around sticky (partially dry) paint. This technique is frustrating and difficult to control. Slick areas of buildup occur, and other spots lift off the canvas. When this happens, it is best to allow the paint to dry thoroughly, then touch it up by first applying Clearblend over the area, then the appropriate colors, and then blending.

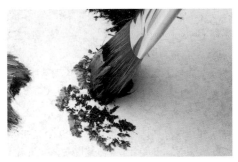

Tapping and Patting

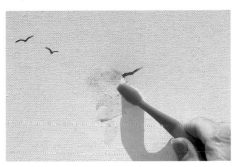

Correcting Mistakes

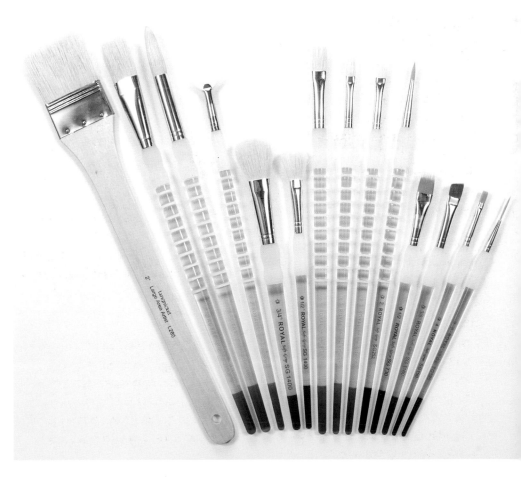

More Brushstrokes

Stroking the Liner

Position the no. 0 liner so that the high-light-side of the brush (the lighter color) is toward the light source when painting.

Double Loading a Bristle Flat

This is a technique you will be using primarily to create grass, shrubs and bushes. Fill the brush with the foliage base color, then lightly pull the top of the brush across the color of the highlight or reflected light.

Marbleize the Colors on a Double Loaded Flat

With the highlight side of the brush turned down, paint an "X" mark on a clean place on your palette, creating various values and colors of the highlight in your brush.

Reshape a Flat for Stippling
With the marbleized highlight side of the brush turned upward, use light pressure to bend the sides of the brush downward to create an irregular rounded shape. Turn the highlighted side of the brush toward the light source when stippling highlights. Reload the brush frequently.

Miscellaneous Supplies

14" × 18" (36cm × 46cm), 16" × 20" (41cm × 51cm), 18" × 24" (46cm × 61cm) stretched canvases

10" × 14" (25cm × 36cm) sheet of 140-lb. (300gsm) cold-pressed watercolor paper

16" × 20" (41cm × 51cm), 18" × 24" (46cm × 61cm) photograph mats

Adhesive paper

Aerosol acrylic painting varnish

Black and white transfer paper

Paper towels

Shipping and masking tape

Small, plastic containers for mixing glazes

Spray bottle

Sta-Wet palette

Stylus

Ultrafine-point waterproof permanent marker or technical pen (black or dark brown)

Brushes

You'll need these brushes to complete the projects in this book.

2-inch (51mm) bristle flat
Nos. 2, 4, 6, 8 and 12 bristle flats
¼-inch (6mm) sable/synthetic flat
No. 4 synthetic detail flat
No. 12 bristle round
No. 2 sable/synthetic round
No. 0 liner
¾-inch (19mm) mop (for blending)
½-inch (12mm) comb
⅜-inch (10mm) sable/synthetic angle
No. 2 bristle fan
Tapered painting knife
Natural sea sponge
No. 2 filbert

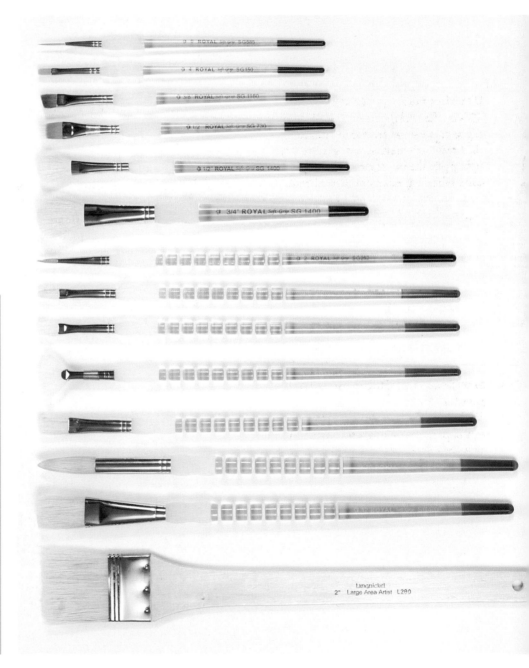

Painting Foliage

Painting realistic foliage can be tough, and as we're going to be doing it a lot in this book on landscapes, here is my basic technique. Create form and shape with the foliage base color, applying it as densely as you desire. Anchor the foliage at its base by stroking some of the wet paint into the earth below. Put lots of taps of reflected light over the foliage, a medium amount of a middle color, and very little of the highlight colors. Notice that each progressively lighter color applied to the foliage extends the top outer portion of the foliage toward the light source, making it slightly fuller and taller.

1 Establish the Foliage
Block in the foliage with the base color, creating interesting shapes with leafy edges.

2 Anchor and Add Reflected Light
Pull some of the foliage base color down into the earth. Stipple, crunch or tap reflected light sparsely over the foliage, being careful not to paint solidly.

3 Begin Highlighting
Highlight the top and outermost two-thirds area of the bush and foliage clusters using a medium value of the foliage highlight color, again not painting solidly, just adding dabs.

4 Add the Sunlit Spots
Add additional dabs of sunlight on the top and outermost one-third area of the bush and clusters within.

Putting Clouds in the Sky

Along with foliage, skies and particularly clouds are a major part of landscape painting. Here's how I paint the big, fluffy clouds that dominate my skies.

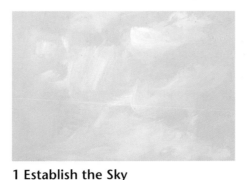

1 Establish the Sky
Loosely apply a generous amount of the sky's base colors with a different large bristle brush for each different color.

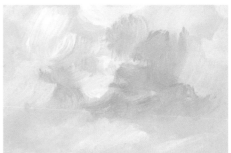

2 Add the Shadows
Quickly apply the cloud's shadow colors into the wet base color.

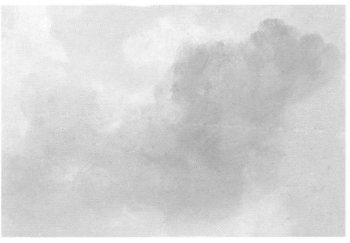

3 Blend the Colors
Blend the sky with a clean hake or duster (a soft, fluffy brush) and allow the sky to dry thoroughly.

4 Highlight the Clouds
Load one corner of a no. 2 fan with Whiteblend and the other corner with a peach color. Place dabs of Whiteblend highlight in an irregular line with the fan wherever you want the top of a puffy spot on a cloud formation to be. Add a dab of peach within the highlight with the other corner.

Generously load a no. 12 round with Clearblend and blot it on a paper towel, leaving the center of the brush fully loaded and ready to blend the highlights. Hold the brush almost flat against the canvas with the handle pointing away from the light source, and tap into the inside portion of the highlight, picking up some of the paint. Tap the brush randomly throughout the cloud to disperse the highlight. Move each subsequent stroke slightly toward the shadow, distributing progressively less paint with each tap. Skip spaces to create multiple puffy spots, and blot to remove some highlight if it's too solid. Scumble to end the highlight gradually and soften slightly with a light touch of a ¾-inch (19mm) mop to blend some brush marks, but not all. Leaving lots of imperfections in the clouds is preferable to smoothly blending them.

Create extended formations by connecting several puffs along the edges to form large billows, and add additional puffy spots within the billows to bring the center portions forward. Continue until the sky is covered with fluffy white clouds.

Riding the Wind

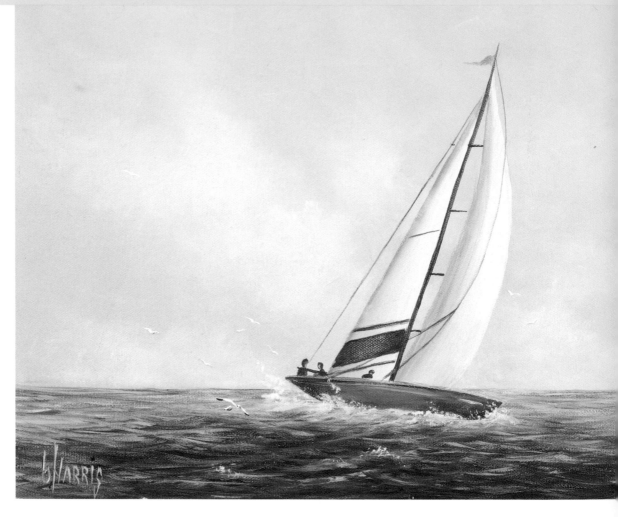

Riding the Wind
11" x 14"
(28cm x 36cm)

Artists have always found seas, lakes and rivers to be fascinating subjects. Today this is still true, and for good reason: Few settings equal the undeniable beauty, splendor and excitement that a body of water provides. It's hard to imagine a time when the power of the marine environment could fail to stir creativity in artists, compelling them to capture nautical landscapes.

Whether you are an experienced artist or a green beginner, get on board for a fun learning experience. Be the captain of your paints and brushes, and you will sail through these fun, quick and easy techniques. For variety, I chose to demonstrate this painting on an 11" x 14" (28cm x 36cm) canvas. However, you don't have to anchor yourself to the size I chose. Enlarge the pattern to suit any size canvas or surface you choose. Aye, aye skipper, now you must man the wheel.

Materials

Acrylic Colors Burnt Sienna, Cadmium Red Medium, Dioxazine Purple, Payne's Gray, Ultramarine Blue, Yellow Ochre

Mediums Clearblend, Slowblend (add ½ of a teaspoon per cup of water in your water container), Whiteblend

Brushes ⅜-inch (10mm) angle, 2-inch (5cm) bristle flat, no. 0 liner, nos. 6 and 12 bristle flats, ½-inch (12mm) comb, no. 2 bristle fan, no. 6 round

Pattern Enlarge the pattern (page 100) 117%

Other 11" x 14" (28cm x 36cm) canvas (or any size canvas you choose, just adjust your pattern accordingly), easel, palette, large water container, black graphite transfer paper, stylus, palette knife, natural sponge, paper towels, acrylic varnish, hair dryer, small container for the medium, tape

Color Mixtures

Before you begin, prepare these color mixtures on your palette.

Brownish Black	Payne's Gray + Burnt Sienna
Cranberry	Maroon + 4 Burnt Sienna + 1 Cadmium Red Medium
Light Gray	15 Whiteblend + 4 Payne's Gray + 1 Ultramarine Blue
Maroon	4 Burnt Sienna + 1 Dioxazine Purple
Navy	3 Payne's Gray + 1 Ultramarine Blue
Peach	Cadmium Red Medium + Yellow Ochre + Whiteblend
Soft White	Whiteblend + a speck of Yellow Ochre
Taupe	Light Gray mixture + a touch of Burnt Sienna + a speck of Dioxazine Purple
Violet-Gray	Whiteblend + Payne's Gray + Ultramarine Blue + Dioxazine Purple

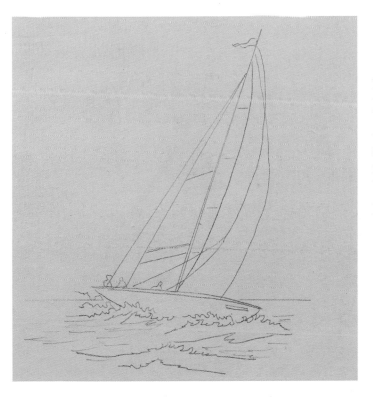

1 Prepare the Canvas and Transfer the Pattern

Prepare the canvas with a basecoat of the light gray mixture applied with a 2-inch (5cm) bristle flat. Make sure to save some of the basecoat to cover any mistakes that might happen later. When the canvas is dry, transfer the pattern onto it.

2 Create the Clouds

Scumble a cloud formation in the sky using small, erratic and somewhat circular strokes of the off-white mixture using a no. 6 bristle flat. After forming a cloud, wipe your brush clean and use it to scrub away any unwanted hard edges. Rinse the brush and add Clearblend to it, if needed, to soften stubborn edges along the bottoms of clouds to create a gradual transition. Should unwanted hard edges remain, touch up with the reserved light gray basecoat. Make sure to keep your brush moving as you scrub, whether applying or blending: Scrubbing in one place too long will lift and remove the paint instead of spreading it. Repeat, scumbling clouds throughout the sky.

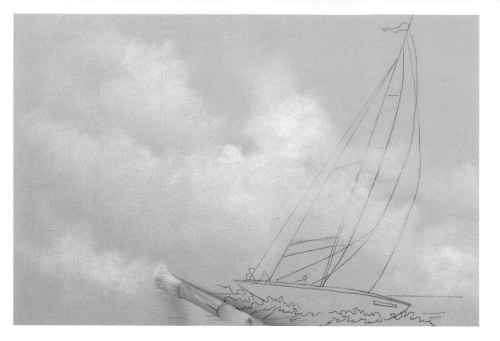

3 Paint the Water

Cover one section of the water at a time with Clearblend using a no. 6 round. Apply the navy mixture over the Clearblend with the chisel edge of your comb in horizontal strokes across the water. Swish the brush back and forth to create short, slightly curved strokes in the water. Make sure to leave some of the basecoat showing for highlights. Use more Clearblend at the horizon to make it lighter and thus appear farther away, and a higher concentration of navy at the bottom to make it come forward. Vary the concentration of Payne's Gray and Ultramarine Blue throughout to create different values.

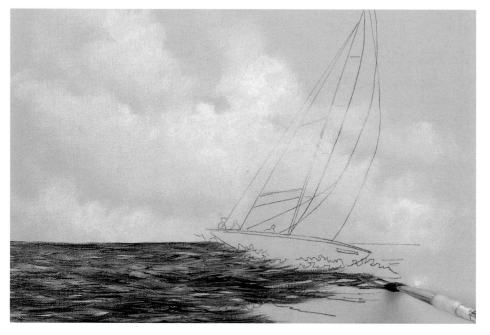

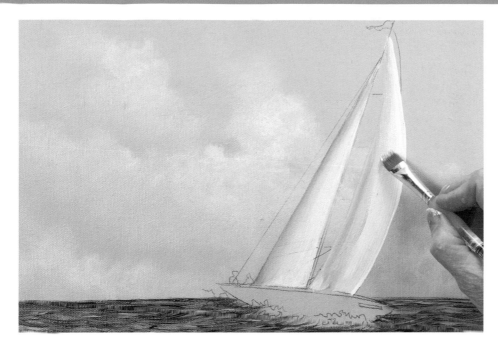

4 Add the Sails

Starting at the leading edge of a sail, apply soft white with the ⅜-inch (10mm) angle. Wipe the excess paint from the brush and use it to apply a taupe shadow along the other side of the sail, overlapping into the edges of the wet, soft white. Blend the two colors together with the tips of your ½-inch (10mm) comb, using light pressure. Repeat for the other sail and allow it to dry thoroughly.

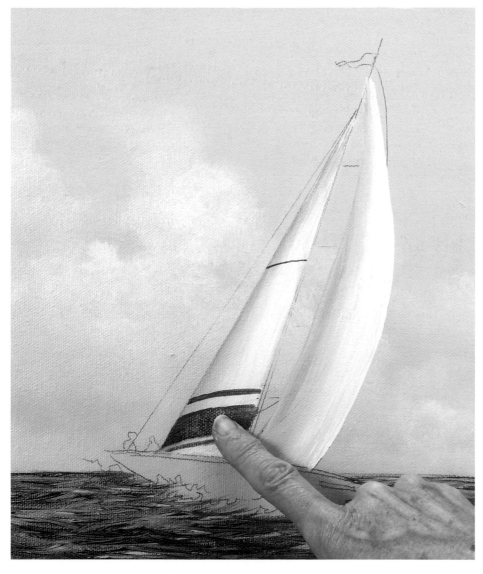

5 Highlight the Sail and Place the Stripes

Moisten a sail with Clearblend using your no. 6 bristle flat. Highlight the right-center portion of the sail with a slightly brighter value of soft white created by adding more Whiteblend, using your ⅜-inch (10mm) angle. Blend the inside edge of the lighter highlight toward the center of the sail with a clean ½-inch (12mm) comb. Repeat for the other sail.

Paint one cranberry stripe at a time and straighten the lines or erase irregularities on the stripes immediately with the chisel edge of a clean, moist ½-inch (12mm) comb. Use the no. 0 liner for thin stripes and the ⅜-inch (10mm) angle for the wide stripe. Blot the wide strip lightly with your finger to create a highlight.

6 Paint the Hull

Paint the hull of the boat with the navy mixture using your ⅜-inch (10mm) angle. Add Whiteblend to the mixture in the brush, creating a medium value blue-gray, and apply it horizontally through the central area of the hull. Wipe the excess paint from the brush and blend, creating a gradual transition between the blue-gray in the central area and the navy at the bow and stern.

After the hull has dried thoroughly, paint the rail across the top of the hull with Yellow Ochre thinned with water to a creamy consistency using your liner brush, and add a bumper at the bow of the boat. Add a little White-blend to the creamy Yellow Ochre on your liner and highlight the front half of the rail.

7 Create the Mast and Rigging

Paint the mast with a diluted mixture of brownish black using your no. 0 liner. Straighten the edges by lifting off the imperfections in the brown with the chisel edge of a clean, moist comb. Dilute the dark brown mixture with a bit more water and Slowblend, and use your liner brush to create the rigging lines (ropes). Straighten crooked or irregular lines with the chisel edge of a clean, moist ½-inch (12mm) comb.

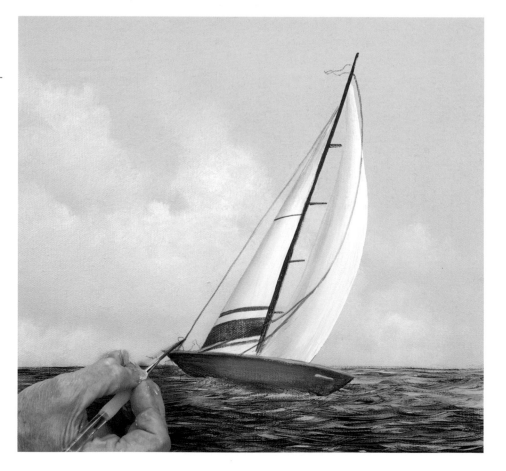

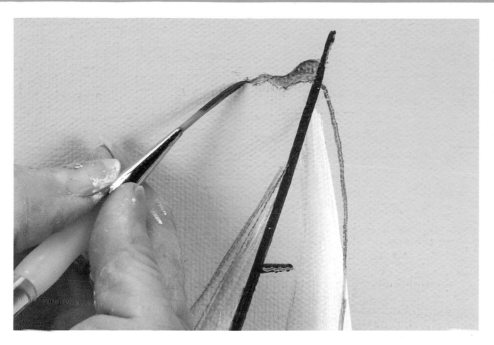

8 Paint the Flag

Using the cranberry mixture diluted with a touch of Clearblend, paint the flag at the top of the mast with your no. 0 liner.

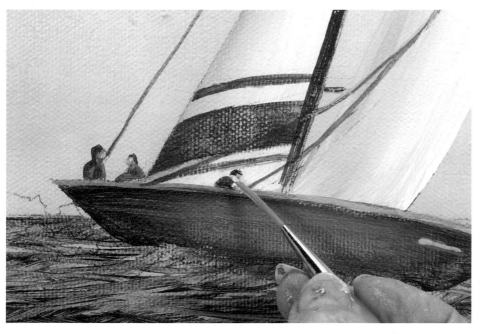

9 Add the Passengers

Paint the hair and shirts of the boaters with maroon using the no. 0 liner. Clean the liner, then use it to highlight their shirts with your peach mixture. Paint their faces and hands with peach using a clean liner.

10 *Make the Water Splash*

Apply Clearblend to the water around the boat with your no. 12 bristle flat. Stipple and crunch splashes around the hull of the boat where it touches the water using your no. 2 fan lightly loaded with Whiteblend. Soften the bottom of the Whiteblend splashes with a ½-inch (12mm) comb moistened with Clearblend.

11 *Blend the Splashes into the Water*

Create water movement and connect the splashes around the boat to the rest of the water by pulling along the bottom edges of the splash with a ½-inch (12mm) comb moistened with Clearblend. Use short, swooping strokes that curve to connect to the previously painted horizontal strokes to create the illusion of movement.

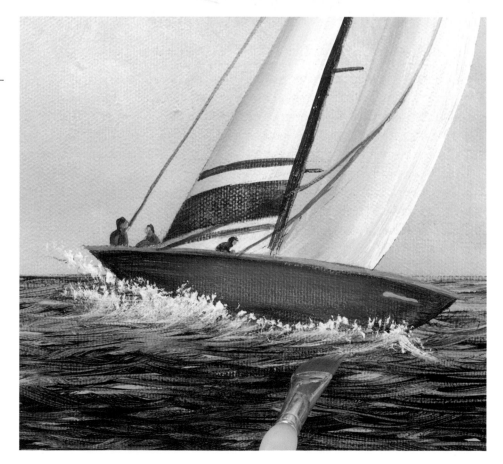

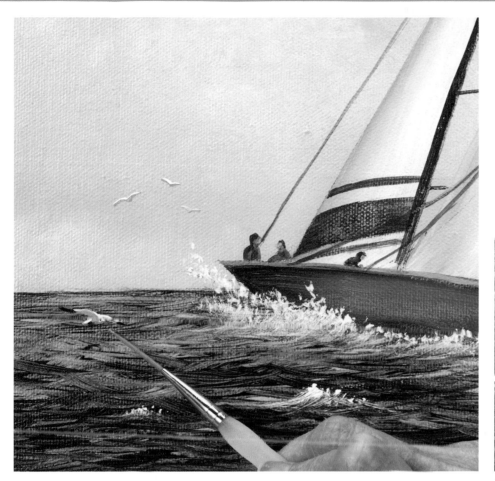

Whitecap Detail

12 *Add Whitecaps in the Foreground and Birds to the Sky*

Moisten the remaining water area with Clearblend using your no. 12 bristle flat. Crunch Whiteblend randomly into the wet Clearblend using a no. 2 fan, then pull the bottom of the whitecaps into the water with swooping strokes—attaching the splashes to the horizontal strokes in that area—with a ½-inch (12mm) comb moistened with Clearblend.

Double load your liner brush with violet gray on the bottom and White-blend on the top and add the birds. Add detail to the largest, foremost bird only: Use your liner to create Payne's Gray wingtips and an eye. Wash the liner and use it to paint an orange beak using brush-mixed peach, Cadmium Red and Yellow Ochre. Add any special markings or additions to the boat as you desire. Sign, then spray your completed painting with a clear aerosol varnish. Sit back and enjoy *Riding the Wind*.

Palm Trees in Paradise

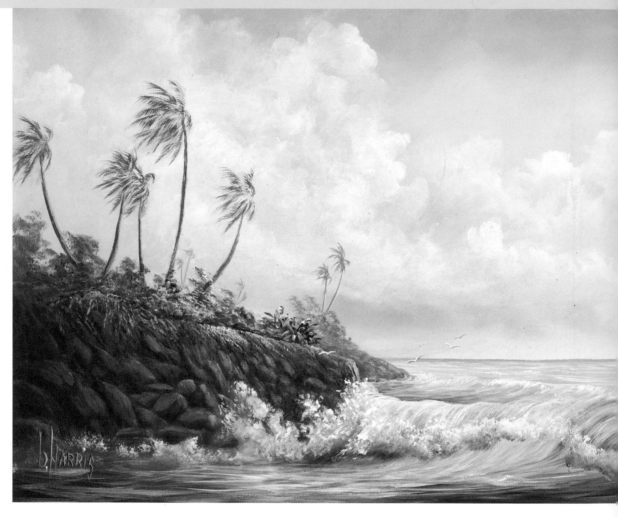

Palm Trees in Paradise
16" x 20"
(40cm x 50cm)

Let your imagination drift away to that place you call paradise. I did just that when I composed *Palm Trees in Paradise*, using my memories of Oahu, Hawaii.

I let the soft trade winds whisper in my ear, bringing back memories of the island's endless contrasting landscapes, from the mountains to the seashore. Oahu offers a visual smorgasbord, from lush green mountains and valleys to white sandy beaches, as well as rugged, lava-encrusted mountains and mammoth stony seashores. Hawaii is truly a land of magnificence, unique beauty and grace; it's awesome and unforgettable in every way.

As I began to compose on the canvas in my mind, I settled on the sight of palms swaying in the balmy Hawaiian breeze, crashing waves hitting the rocky shore, and the aroma from fragrant flowers. Even the melody of a distant ukulele floated through my senses.

In this lesson, you will learn how to paint smooth color transitions in the sky, and then learn to enhance it with a cloak of colossal, billowing clouds. You also will use value change and scale to create the illusion of depth in the sky, land and water. Mastering these techniques will allow you to paint your memories no matter where they take you. As you paint *Palm Trees in Paradise*, think of how you can use these techniques to depict your imagined paradise.

Materials

Acrylic Colors Burnt Sienna, Burnt Umber, Cadmium Red Light, Cadmium Red Medium, Cerulean Blue, Dioxazine Purple, Hooker's Green Deep (if you can't find this exact shade, just add black to your Hooker's Green), Payne's Gray, Ultramarine Blue, Vivid Lime Green (Thalo Yellow Green), Yellow Ochre

Mediums Clearblend, Slowblend (add ½ of a teaspoon per cup of water in your water container), Whiteblend

Brushes 2-inch (5cm) flat, nos. 4, 6, and 12 bristle flats, no. 12 round, ⅜-inch (10mm) angle, no. 0 liner, no. 4 detail flat, ½-inch (12mm) comb, no. 2 bristle fan, ¾-inch (19mm) mop

Pattern Enlarge the pattern (page 101) 200%

Other 16" x 20" (41cm x 51cm) canvas, easel, palette, large water container, black graphite transfer paper, stylus, palette knife, natural sponge, paper towels, acrylic varnish, hair dryer, small container for the medium, tape

Color Mixtures

Before you begin, prepare these color mixtures on your palette.

Charcoal	1 Payne's Gray + 1 Burnt Umber + only a touch of Whiteblend
Deep Ocean Blue	3 Ultramarine Blue + 1 Payne's Gray
Light Cerulean	1 Cerulean Blue + 10 Whiteblend
Medium Gray	6 Ultramarine Blue + 3 Burnt Sienna + 1 Dioxazine Purple + 50 Whiteblend
Light Gray	3 Medium Gray mixture + 1 Whiteblend
Light Gray-Green	Light Gray mixture + Hooker's Green Deep + 1 Burnt Umber
Medium Gray-Green	Light Gray-Green mixture + more Hooker's Green Deep + Burnt Umber
Deep Green	Medium Gray-Green mixture + more Hooker's Green Deep + Burnt Umber
Light Lime Green	Vivid Lime Green + Whiteblend
Bright Yellow-Green	Light Lime Green + a touch Yellow Ochre + Whiteblend
Light Teal	1 Cerulean Blue + 1 Vivid Lime Green + 1 Whiteblend
Off-White	Whiteblend + a speck of Cadmium Red Light
Peach	1 Yellow Ochre + 1 Cadmium Red Light + 20 Whiteblend
Sky Blue	4 Ultramarine Blue + 1 Burnt Umber + Whiteblend

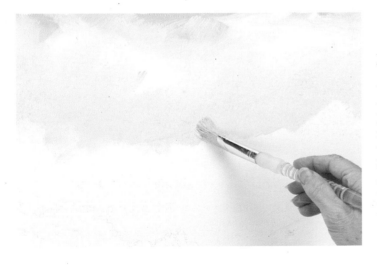

1 *Transfer the Pattern and Paint the Sky*

Transfer the pattern to your canvas, leaving out the palm trees and foliage. You will add them later, after the sky is painted and dry. Using your 2-inch (5cm) bristle flat, lay in your sky blue mixture at the very top of the canvas with loose, large strokes. Add Whiteblend and the light teal mixture as you move down the canvas, making the sky colors progressively lighter through the central area. Add light gray in the lower portion of the sky using the no. 12 bristle flat.

2 *Add the Cloud Shadows*

Add light and medium gray to a corner of the uncleaned 2-inch (5cm) bristle flat you used for the sky and add shadows for the cloud banks drifting up and down, using erratic, somewhat circular strokes for the billowing areas and horizontal strokes along the bottom. Place touches of medium gray horizontally along the bottom of the lowest cloud bank and blend upward. Continue to the next step before the paint dries.

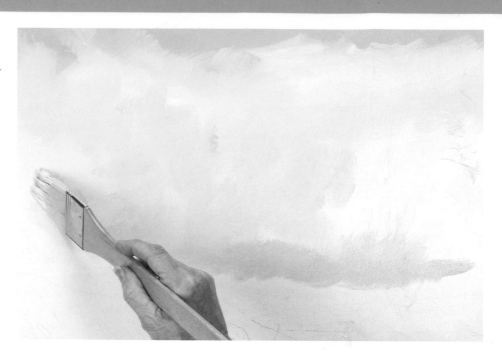

3 *Blend the Cloud Colors*

Blend the sky blue, teal, white and gray of the sky with a clean, dry no. 12 bristle flat along their edges. Soften and create a smoother blend using a ¾-inch (19mm) mop, using erratic and somewhat circular strokes with a very light touch. Don't be overly concerned about blending out all the imperfections within the billowing clouds—you can place highlights over the unattractive spots! Wait until the sky dries thoroughly before touching up or adding highlights.

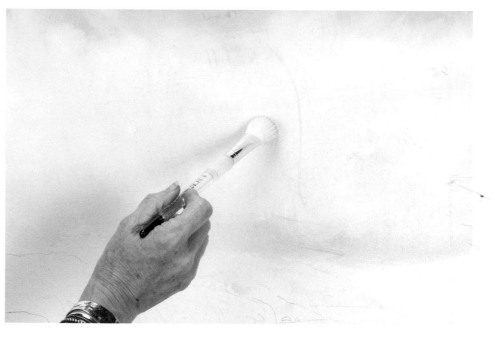

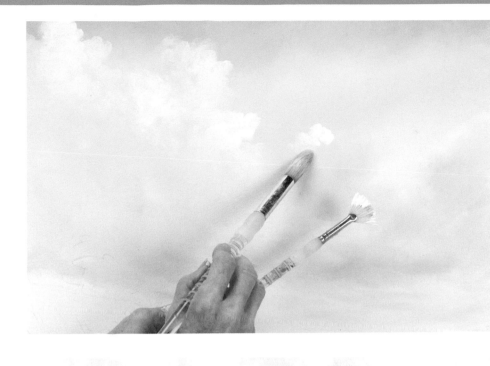

4 Add the Highlights

Fully load your no. 12 round with Clearblend. Wipe off the excess, but don't squeeze it out. Lightly load the corners of your no. 2 bristle fan, one corner with Whiteblend and the other with your off-white mixture. Apply a little off-white and Whiteblend with your fan (far more Whiteblend than off-white, typically), then spread the inside edges of the wet highlight paint using tapping, circular strokes with the Clearblend and no. 12 round bristle. Use a clean, moist sponge to erase clouds that are unpleasing before they dry, and try again until you have mastered the technique. Continue until the sky is covered with fluffy, white clouds.

5 Paint the Distant Water

Using the ⅜-inch (10mm) angle brush, paint light and medium gray alternately across the canvas at the horizon line. With the same brush, place teal through the central section and alternate sky blue and deep ocean blue in the foremost portion. Blend the colors together using a no. 2 bristle fan with loose, horizontal strokes. Apply a short, wiggly, horizontal dash of Whiteblend through the back half of the distant water with a no. 0 liner. Create a whitecap by blending that dash's endings horizontally outward, then ruffle the top and blend the bottom with a ½-inch (1cm) comb. Repeat, adding larger and more defined whitecaps as you move toward the foreground.

6 Create the Crest of the Background Wave

Crunch splashes along the crest of the foremost distant wave using your no. 2 fan with Whiteblend. Pull down from the bottom of the splashes in a swooping motion to connect the splashes to the flat water, and define the movement of the water using a ½-inch (12mm) comb moistened with Clearblend. Add Whiteblend to the comb brush and place additional water ripples throughout the flat area of the foremost water, swooping to connect to the splashes.

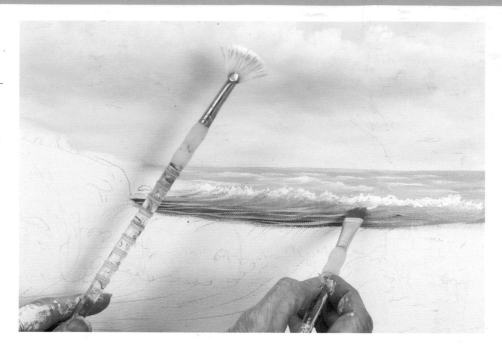

7 Paint the Bluffs

Use the medium gray mixture with your ⅜-inch (10mm) angle to create the distant bluff. Add a little of the charcoal mixture to your angle and tap a slightly darker rocky texture over the gray. With the medium gray brush-mixed with peach, create curved boulders and rocks with your no. 4 detail flat.

With your no. 12 bristle flat, apply the charcoal mixture to the foreground bluff with rough, choppy strokes, coming down at a slight slope. Add a little bit of Whiteblend to your no. 12 bristle flat and use curved strokes to add slightly lighter boulders of different sizes and shapes. Make the rocks on the left side of the canvas larger and those on the right smaller, which will make the left side appear closer to the viewer. With a clean ⅜-inch (10mm) angle, soften the left edges and bottoms of the rocks into the cliff. If more depth is needed, darken the left side with charcoal.

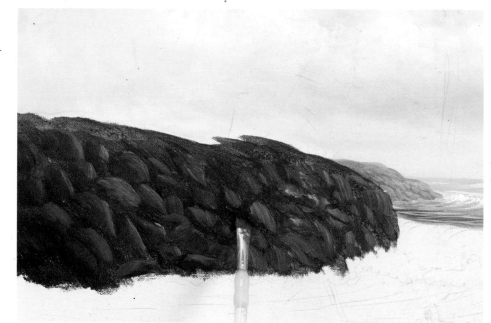

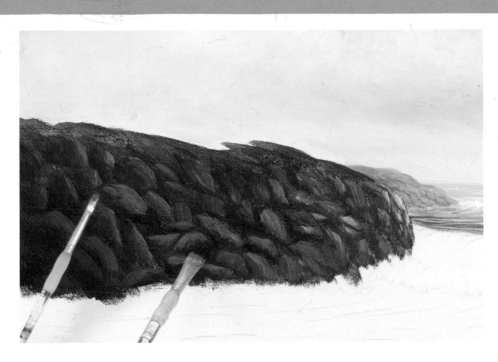

8 *Highlight the Bluffs*

Let the foreground bluff thoroughly dry. Moisten it with Clearblend using a no. 6 bristle flat, then begin to add highlights. With different values of brush-mixed charcoal and peach on your no. 4 bristle flat, use the edge of your brush to lightly add highlights to the rocks, using more peach in the highlight mixture on the right of the bluff and progressively less toward the left side. Don't highlight every rock— it will be more interesting and realistic if the highlights are random.

Brush-mix equal parts charcoal and Clearblend into your ½-inch (12mm) comb. Use it to soften the highlights and make the rocks appear more jagged, and also to randomly deepen some shadows between them.

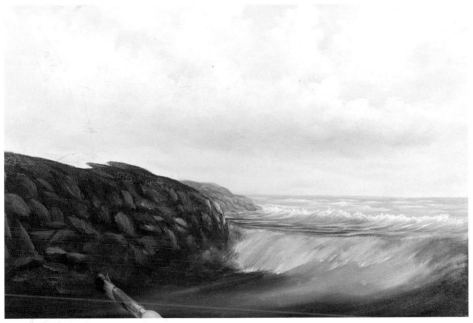

9 *Paint the Foreground Water*

Using your no. 12 bristle flat, lay in the deep ocean blue mixture with short sideways strokes along the boulder and the bottom of the canvas and up the right side. With your no. 6 bristle flat lay in the light teal mixture through the middle, blending it with the darker blue in the direction of the water flow. Make your strokes horizontal in flat areas and swooping to follow the direction of the water in others. Use both brushes to blend for the best color mixtures.

Using the same no. 12 bristle flat with the deep ocean blue mixture and teal still in it, scumble over the bluff where the splashes hit it. Paint the curl of the foreground wave using a ½-inch (12mm) comb, alternating between light teal, light Cerulean and deep ocean blue. Clean the brush frequently to avoid mixing or muddying the colors.

10 Detail the Foreground Wave

Let the painting dry, then cover one section of the foreground water at a time with Clearblend using the ½-inch (12mm) comb. Over the Clearblend, use the same brush to add in deep ocean blue, light teal, light Cerulean and Whiteblend wherever they may be lacking. Spread the colors randomly throughout the water to capture the motion and lend realism.

With just the tip of your ½-inch (12mm) comb, use Whiteblend to highlight the foreground wave. Use curving downward strokes and leave streaks to imply the direction and movement of the water. With the no. 2 fan, crunch in Whiteblend wherever the splashes break. Underneath the white, randomly tap in light teal and deep ocean blue, working one section at a time and keeping the line irregular. Blend with the tip of the ½-inch (12mm) comb, but be sure to leave the tips frothy. Smooth the bottom of the splash lightly with the ¾-inch (19mm) mop. Repeat for the splashes along the bluff.

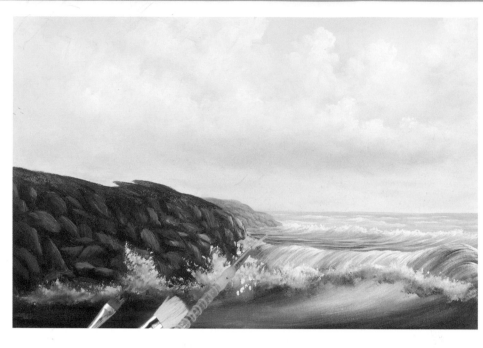

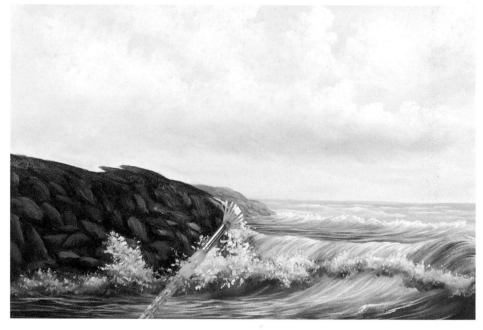

11 Finish the Water

Apply Clearblend with your no. 2 fan to one section of the water at a time. With the ½-inch (12mm) comb, add curved ripple lines to the lightest area of water, indicating the direction of the flow with Whiteblend and a touch of light Cerulean. Soften some of the ripple lines with your finger. Add ripples in the remaining foreground water with the same brush and a mixture of light Cerulean and dark ocean blue, making the color darker in the darkest sections of the water. Randomly blot portions of the ripples to subdue them. Use the corner of the fan brush to tap a few bold splashes crashing against the right side of the foremost bluff, randomly blotting the bottoms of some with your finger but leaving the tops bold.

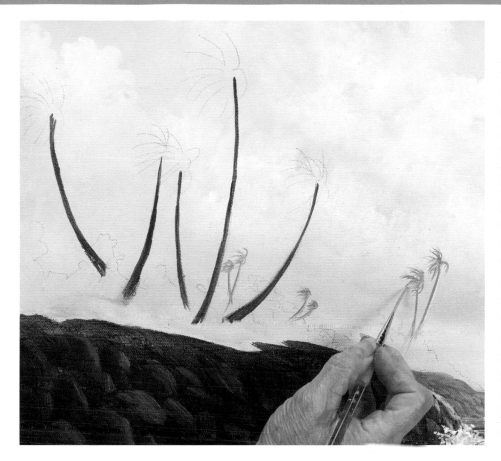

12 Begin the Palm Trees

Trace your trees onto the bluffs. For the trees in the distance, use your no. 0 liner to apply the light gray mixture. Highlight the two trees at the far right side of the distant bluff with your peach mixture. Add a touch of light gray to the peach and use it to highlight the remaining distant tree trunks and also to create their fronds. Create a light gray-green by adding a touch of the deep green and a speck of Burnt Umber to your brush, and use that color to create the palm fronds on the palms at the far right side of the distant bluff. Using your no. 0 liner, paint the trunks of the foreground trees with charcoal brush-mixed with a touch of medium gray. Make sure the trunks overlap for a more natural appearance.

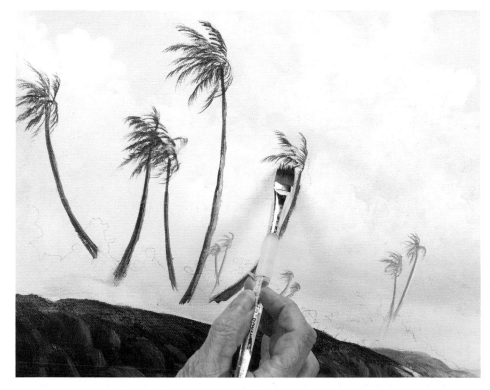

13 Highlight the Trunks and Add More Fronds

Highlight the foreground tree trunks with your ½-inch (12mm) comb held vertically, using a bright, vivid peach created by brush-mixing more Cadmium Red Light and Yellow Ochre to the peach.

Lightly dilute your deep green mixture with water to a creamy, not quite fluid texture and paint the fronds of the foreground trees with a clean ½-inch (12mm) comb, lightly stroking in a curving motion.

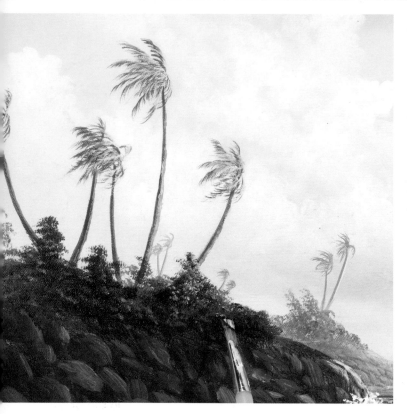

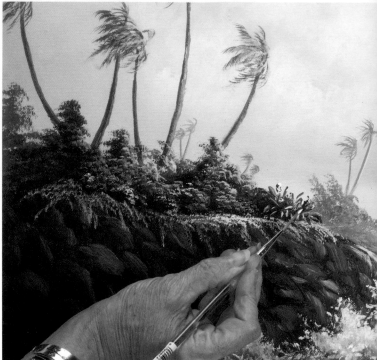

14 Finish the Trees and Begin the Foliage

With a diluted light Cerulean mixture, add the reflected light of the sky to some of the foreground palm fronds with your ½-inch (12mm) comb. Highlight the fronds with the light lime green mixture diluted to a creamy texture using your ½-inch (12mm) comb. Use curved strokes and begin at the stem running through the middle of the frond.

Using your no. 6 bristle flat, apply the light gray-green mixture at the base of the distant trees for the background foliage. Blot the base of the distant foliage, creating a gradual transition between it and the bluff. Use the same brush and mixture on the farthest left-hand trees to move them to the background. Using the same brush, create the base of the foreground foliage with the deep green mixture. Tap reflected light from the sky into the dark foliage with the light Cerulean mixture double loaded on the top side of the uncleaned no. 6 bristle flat.

15 Finish the Foliage

Double load light lime green onto the light Cerulean side of your uncleaned no. 6 bristle flat and tap highlights onto the top and front of the foliage. For the foliage that spills over the face of the bluff, use the ½-inch (12mm) comb double loaded with deep green on the bottom and light lime green on the top. Tap the paint gently onto the rocks. Tap highlights in the central area of this foliage with your ½-inch (12mm) comb and the bright yellow-green mixture.

Using the corner of your ½-inch (12mm) comb and a marbleized blend of Ultramarine Blue and Whiteblend, gently tap flowers into the foliage. Repeat this process with marbleized blends of Cadmium Red Medium with White-blend and Dioxazine Purple with Whiteblend. To create the leaves of the calla lilies, double load your liner with the light lime green on one side and the deep green on the other. Use a light press-and-release motion as you stroke to paint individual leaves onto the right side. After they have dried, clean your liner and double load it with Cadmium Red Medium and Whiteblend, and add the lilies by gently squiggling the tip of the brush on the canvas.

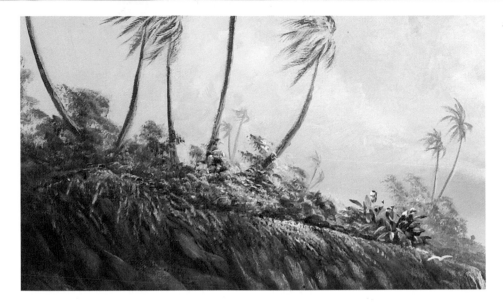

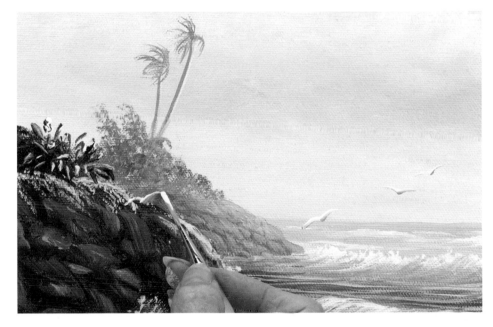

16 *Add the Birds*

Using your no. 0 liner double loaded with sky blue on the bottom and Whiteblend on the top, add the birds. The largest bird should be crossing over the foremost bluff. Sign and dry your painting, then spray it with a clear acrylic varnish. Listen to the sounds of the surf as you enjoy your *Palm Trees in Paradise*.

Out for a Stroll

When you think of lush southern landscapes and flower gardens, do southern belles of years gone by come to mind? In strolling through the historical areas of St. Simons Island, Georgia, I kept thinking that the only thing missing in the pristine gardens of Epworth By The Sea were elegantly dressed southern belles. So, while out for an afternoon stroll, I used my imagination and artistic prerogative to design this composition. Later in my studio I recorded it on canvas.

Not only is this a lovely landscape, it is also a great exercise in learning how to add figures to your landscape. Please allow me to stroll with you through this painting pleasure.

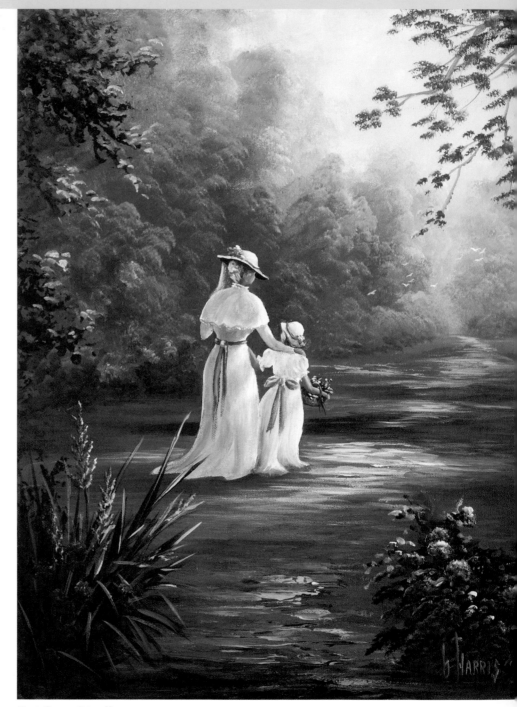

Out for a Stroll
20" x 16" (51cm x 41cm)

Materials

Acrylic Colors Burnt Sienna, Burnt Umber, Cadmium Red Medium, Cadmium Yellow Medium, Cerulean Blue, Dioxazine Purple, Hooker's Green Deep Hue (or add black to Hooker's Green on your palette), Ultramarine Blue, Vivid Lime Green, Yellow Ochre

Mediums Clearblend, Slowblend (add ½ teaspoon per cup of water in your water container) Whiteblend

Brushes ⅜-inch (10mm) angle, no. 0 liner, no. 2 round, no. 4 synthetic flat, nos. 2, 6, 8 and 12 bristle flats, ½-inch (12mm) comb, no. 2 bristle fan, ¾-inch (19mm) mop, ½-inch (12mm) angle

Pattern Enlarge the pattern (page 102) 182%

Other 16" x 20" (41cm x 51cm) canvas, easel, wet palette, large water container, label paper (adhesive-backed paper for design protector), black graphite transfer paper, stylus, palette knife, natural sponge, paper towels, hair dryer, small container for the medium, tape

Color Mixtures

Before you begin, prepare these color mixtures on your palette. Also, brush-mix colors as you go along to add variety.

Bright Peach	Cadmium Red Medium + Cadmium Yellow Medium + a touch of Whiteblend
Bright Yellow-Green	Vivid Lime Green + a speck of Cadmium Yellow Medium + a touch of Whiteblend
Celery Green	10 Whiteblend + 4 Vivid Lime Green + 1 Cerulean Blue + 1 Hooker's Green Deep Hue
Dark Blue-Green	3 Cerulean Blue + 1 Hooker's Green Deep Hue + a touch of Whiteblend
Light and Medium Cerulean	Whiteblend + a speck of Cerulean Blue
Light and Medium Pink	Whiteblend + a touch of Cadmium Red Medium
Light and Medium Yellow	Whiteblend + a touch of Cadmium Yellow Medium
Off-White	Whiteblend + a touch of light yellow mixture
Maroon	4 Burnt Sienna + 1 Dioxazine Purple
Pastel Gray-Green	20 Whiteblend + 2 Cerulean Blue + 4 Vivid Lime Green + 1 Hooker's Green Deep Hue
Light Celery	pastel gray-green mixture + Whiteblend + a touch of Cadmium Yellow Medium
Light Gray-Green	pastel gray-green mixture + a speck of Hooker's Green Deep Hue
Medium Gray-Green	light gray-green mixture + a touch of Cerulean Blue + a speck of Hooker's Green Deep Hue
Turquoise	3 Cerulean Blue Hue + 1 Hooker's Green Deep + 1 Whiteblend

1 Prepare the Canvas and Paint the Sky

Trace the design onto your canvas: The top of the woman's hat should be 7" (18cm) down from the top and 6 ½" (17cm) from the left edge of the canvas. Prepare and place a design protector over the figures to retain the tracing. Creating this peel-out will preserve the white space.

Using the no. 12 bristle flat, begin the blustery sky using the light and medium pink mixtures. Add your light cerulean mixture to the brush and overlap into the pink through the middle of the sky. Use a light and varied side-to-side stroke to create a gradual transition between the colors. Add medium Cerulean into the brush for the lower portions of the sky, making it slightly darker.

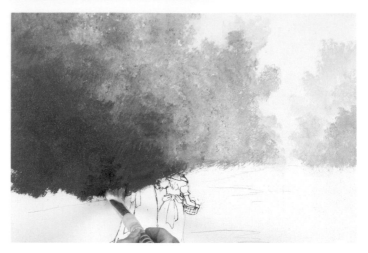

2 *Blend the Sky*

Using a ¾-inch (19mm) mop, blend the colors of the sky together. Soften the brushstrokes to create a gradual transition between colors and make the sky appear smoother and more realistic. Continue on to step 3 before the sky dries.

3 *Create the Distant Foliage*

Stipple pastel gray-green foliage over the bottom of the sky using a no. 12 bristle flat. Using the same brush, stipple light gray-green foliage overlapping the bottom portion of the pastel gray-green foliage. The foliage should become darker as it moves forward with the darkest value in the lower left portions. Create the gradation of colors and values in the foreground, lefthand foliage by intermittently adding the light gray-green, medium gray-green and dark blue-green mixtures to the same uncleaned brush. Scumble to cover large areas, forcing the paint down into the pores of the canvas, and quickly stipple over the wet paint to leave texture.

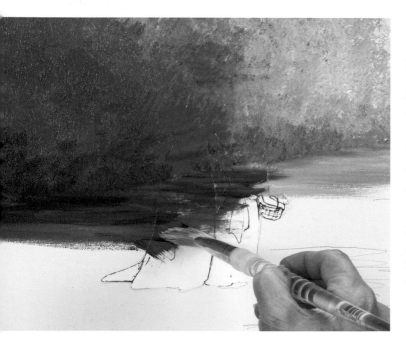

4 *Establish the Grass*

Work a small section at a time when applying and blending the ground colors, holding your brushes horizontally and making all strokes horizontally across the canvas. Should the ground or path colors become sticky while you are working in an area, soften harsh edges quickly then stop and dry it. Remoisten the area with Clearblend before continuing to add and blend colors.

Start in the most distant area of the ground with light gray-green and a no. 8 bristle flat, adding medium gray-green to the brush as you move lower on the canvas to make the ground values correspond with the foliage in each area.

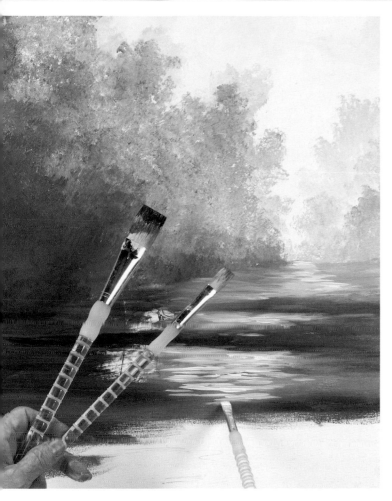

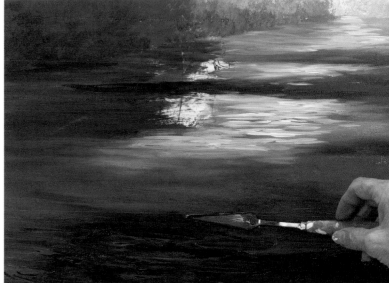

6 Establish the Trail

Paint the remainder of the ground down to the bottom of the canvas with mixtures of medium gray-green and dark blue-green, making the mixture darker as you come forward. Using your palette knife held flat against the canvas, add dashes of maroon, the dark blue-green mixture, Cerulean Blue, Burnt Sienna, Burnt Umber and Dioxazine Purple to the central area of the foreground one at a time in horizontal strokes. Randomly apply the colors and mix them together on the canvas with the knife. Soften the harsh edges with a no. 6 bristle flat, bringing some of the foreground green colors into the outer edges of the dirt colors.

5 Add the Shadows and Highlight the Ground

Use medium gray-green on your no. 8 bristle flat to establish the middle values in the ground. For variety, randomly increase the brightness and change the color by brush-mixing in Vivid Lime Green, Yellow Ochre and Whiteblend, being careful to retain tonal harmony between the ground and the foliage. Create the ground shadows with your no. 12 bristle flat by adding incremental amounts of dark blue-green and alternating with Hooker's Green Deep. Add the sunlit spots with a no. 2 bristle flat using celery, light celery and bright yellow-green. For the lightest and brightest sunlit spots, sparingly use a marbleized brush-mixture of Cadmium Yellow Medium and Whiteblend. Add progressively less of this highlight color as you proceed toward the shaded foreground area; add random dashes of dark blue-green and Hooker's Green Deep to the foreground with a no. 12 bristle flat and blend.

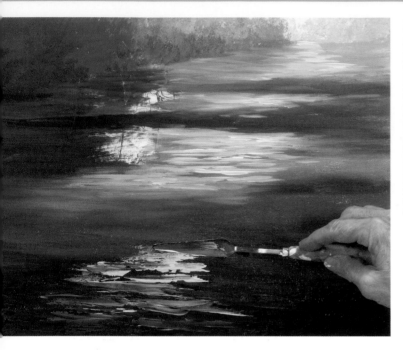

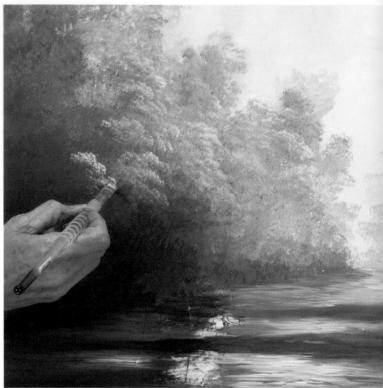

7 Highlight the Trail

Using your medium pink mixture plus a little more Cadmium Red Medium, apply streaks over the dark foreground colors. This will detail the opening of the path your southern belles are strolling down. Then, with the chiseled edge of your ½-inch (12mm) comb, add horizontal dashes of the light pink mixture across the distant meadow. This helps establish the ending of the path.

When the painting is dry, moisten the distant ground area with Clearblend using a no. 2 fan. With the chiseled edge of a ½-inch (12mm) comb, add horizontal dashes of the medium pink toned slightly with a touch of Burnt Umber to indicate patches of earth showing in the distant meadow. Blend the outer edges of the dashes with the Clearblend-moistened fan.

8 Highlight the Foliage

Double load your no. 2 flat with the pastel gray-green on bottom and light yellow on top. Bend the sides of the brush downward to create a rounded top. Stipple clusters of highlight dabs onto the top right sides of of the background foliage. Blot with your finger to blend the lighter colors into the darker, shadowed areas of the trees. Skip spaces between the clusters and reload and reshape the brush frequently. For stronger highlights, angle the brush toward the light source; for weaker highlights, tilt the brush toward the shadow. Add an occasional touch of the celery mixture to the yellow side of the brush and the light gray-green mixture to the green side of the brush to darken the highlights as you move toward the foreground.

Highlight the darker trees in the middle ground using a no. 6 bristle flat double loaded with the medium gray-green mixture on bottom and celery mixture on top. Add dark blue-green to the bottom of the brush for the darkest foreground trees.

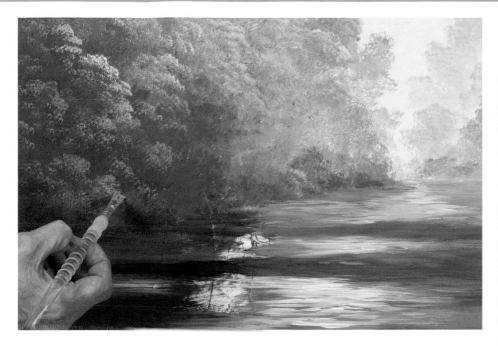

9 Add Flowering Shrubs to the Background

Brush-mix Dioxazine Purple with Whiteblend, Ultramarine Blue with Whiteblend, and various values of Cadmium Red Medium with Whiteblend on your palette, and tone them all with a touch of your light gray-green mixture. Using your no. 6 bristle flat, stipple random clusters of flowering shrubs into the distant foliage. Blot the bottoms to recede them into the foliage. Add a touch more of the light gray-green to these colors and add them into the dark portions of the trees to make them appear farther away. Blot the bottoms with your finger.

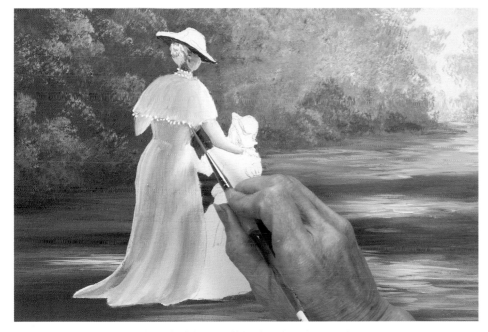

10 Begin the Ladies

Using the bright peach mixture, paint the woman's face with your liner. Place a highlight of light yellow on her cheek and a maroon shadow on her neck and in her ear, then blend. Use medium yellow for her hair and shadow it with Burnt Umber mixed with a touch of maroon and blend.

Apply and blend the dress one small section at a time. Using the ⅜-inch (10mm) angle, paint the woman's dress with various values of brush-mixed Cerulean Blue and Whiteblend. Use a no. 4 synthetic flat with Whiteblend to create the folds and creases in the dress. Blend with a clean angle brush. Paint the shawl with your brush-mixed Cerulean Blue and Whiteblend in the shadowy areas and just Whiteblend in the sunlit areas, then blend. To make the lace around the edges of her collar and shawl, apply tiny dots of Whiteblend with the tip of your liner.

Peel Off the Design Protector

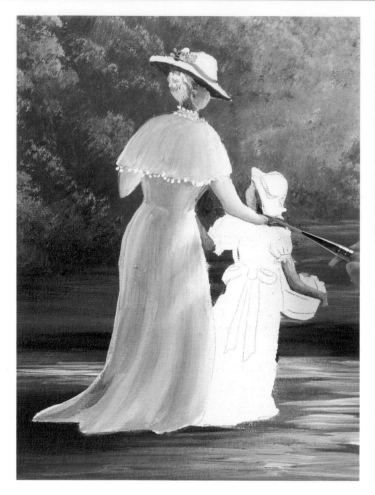

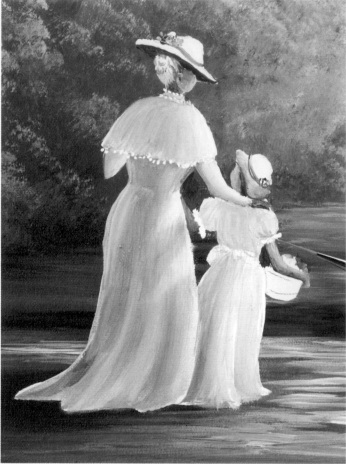

11 Paint the Woman's Hat and Begin the Girl

Paint the woman's hat with the light yellow mixture using your liner brush. Add Whiteblend highlights, blend, then wash the liner and use it to paint the ribbon with brush-mixed Cerulean Blue and White. Double load your liner with Cadmium Red Medium and Whiteblend and swirl it in a circular motion to make it appear to be a bundle of small flowers. Add leaves to the flowers using your clean liner and Vivid Lime Green with a touch of white.

Paint the woman's hand bright peach shadowed with maroon using your liner, and blend. Paint the little girl's face and arms with the same brush and colors as you used for the woman's face. Clean the liner brush and use it to blend the dark and light fleshtones together for a soft transition. Paint the woman's hair medium yellow with shadows of Burnt Umber mixed with maroon.

12 Finish the Little Girl

Paint the little girl's dress using your ⅜-inch (10mm) angle brush and varying values of Dioxazine Purple brush-mixed with Whiteblend. Use your no. 4 synthetic flat and Whiteblend to create the folds and creases, then blend with a clean liner. Using your light pink mixture, define the top edges of the folds with your no. 4 synthetic flat. Reflect some of the blue from the woman's dress onto the girl's dress in the violet, shadowy areas with Cerulean Blue.

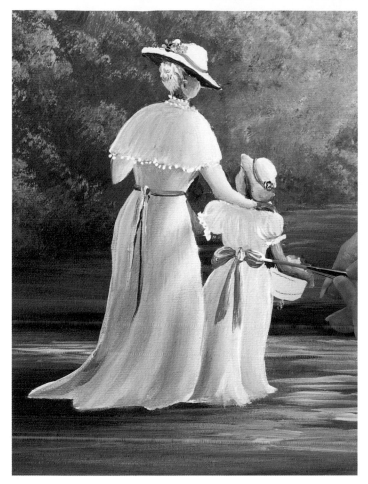

14 Paint the Basket

Using your liner, paint the little girl's basket with Burnt Umber. Highlight it with the off-white mixture using the same brush. Use Hooker's Green Deep with your liner for the leaves in the basket. When it's dry, dab flowers into the basket with your liner and brush-mixed Ultramarine Blue and white, medium yellow and Whiteblend, and Cadmium Red and white. After the flowers are in and the foliage is dry, create a handle across the girl's arm using your clean liner, double loaded with Burnt Umber and off-white.

13 Add the Bows and Final Highlights to the Dresses

Moisten the woman's shawl with Clearblend using your ½-inch (12mm) comb, then add off-white to the crest of her shoulder with your no. 4 synthetic detail flat. Blend the inside edge of the off-white blend toward the shadow area with your ½-inch (12mm) angle. When you are satisfied with the shawl, embellish the sunlight streaks across the front of her dress in the same manner. Repeat on both hats. Accent and highlight the top of the little girl's sleeves and the crest of the folds on the right side of her dress with off-white in the same way. While the girl's dress is moist, touch up the pink and add a hint of light Cerulean blue as reflected light from the woman's dress in some of the shadowy folds. Blend to soften.

Paint the ribbons down their backs with maroon using your liner. Cover the maroon, leaving little bits showing through, with the marbleized, brush-mixed Cadmium Red Medium and Whiteblend. Using off-white, highlight the knots, the folds in the bows and the right side of each sash with your liner.

15 Finish the Foreground Bushes

Use Hooker's Green Deep to fill in the center of the foreground flower bush on the right with your comb and add some tall, spiky leaves and sems protruding outward. double load a comb with Hooker's Green Deep and bright yellow-green and add more tall, spiky leaves. Double load your comb with medium Cerulean Blue and Hooker's Green Deep and use it to create individual leaves. Clean the comb, then double load it with Dioxazine Purple and Whiteblend. Using the very edge of the brush, tap slanted, downward flowers over the foreground bush. Fan the brush out at the bottom to create a larger base for the flower.

Stipple random sizes of unevenly shaped hydrangea blooms into the bush with a no. 6 bristle flat using brush-mixed Dioxazine Purple and a touch of Whiteblend. Rinse the brush, then double load it with Ultramarine Blue and Whiteblend. Holding the brush perpendicular to your palette, tap it on the palette until there are three defined values in the brush. With the light side of the brush on top, crunch highlights onto some of the larger blooms on the top of the bush. Use only the corner of the brush for the smaller blooms. Double load the no. 2 synthetic round with turquoise and bright yellow-green and add detailed leaves along the top of the bush and around some of the flowers.

Using the no. 6 bristle flat, block in the bush on the right side by stippling on Hooker's Green Deep. Double load the same brush with your turquoise mixture and Hooker's Green Deep and stipple tiny dabs of shadowy reflected light.

16 Create the Foreground Trees on the Left and Right

Use a no. 12 bristle flat to stipple leaf-like dabs of Hooker's Green Deep onto the upper left corner to create a tree. Highlight the tips on the right side of the tree with your no. 2 round double loaded with the light yellow-green mixture on top and Hooker's Green Deep on the bottom.

Using a mixture of Burnt Umber and Whiteblend double loaded with light pink, paint the tree branches of the upper right tree with your liner. Stir Ultramarine Blue into your liner, which makes gray, then double load it with the light pink to make some gray limbs.

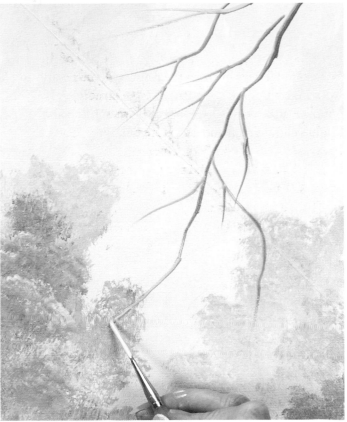

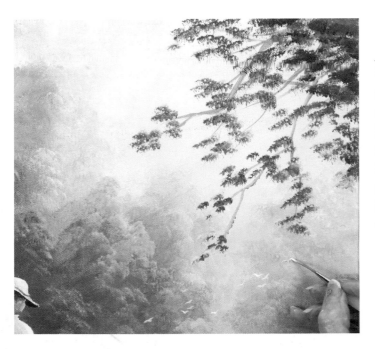

17 Finish the Painting

Use a no. 2 bristle flat and Hooker's Green Deep to stipple the darkest values of the tree's leaves in the top right corner of the canvas. Double load a no. 2 bristle flat with Hooker's Green Deep and the medium gray-green mixture for the center leaves and middle values. Double load the same brush with the light yellow-green and medium gray-green mixtures for the highlights at the tips. Paint in the covey of birds with your liner double loaded with the leftover gray from the tree limbs and Whiteblend.

Lazy River

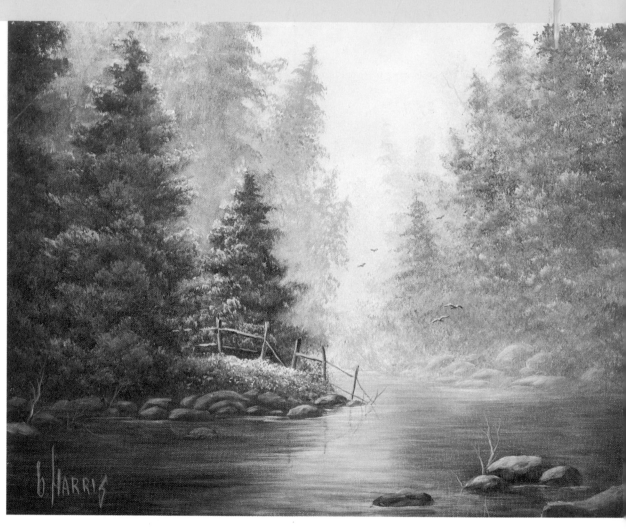

Lazy River
14" × 18"
(35cm x 45cm)

Sometimes, when the conditions are right, our familiar landscape is enveloped with an eerie but beautiful fog. In the morning or around nightfall, large lakes and rivers are often cloaked in a blanket of fog that creates a lazy, mysterious mood.

Although we think of air as being transparent, it is more translucent than clear. The air actually contains particles that obscure our vision, making things in the distance a bit vague, less vivid in color and lacking strong value contrast. We don't consciously see these particles, yet they are there. We only see their effects. Often, it is like seeing things through a veil.

Because of the quick-drying nature of acrylic paints, they lend themselves beautifully to the use of glazing techniques to create this spatial atmospheric phenomenon. We are going to use a glazing technique to create a foggy, misty atmosphere between the foreground foliage and the distant foliage, increasing the depth in this scene of a *Lazy River*.

Materials

Acrylic Colors Burnt Sienna, Burnt Umber, Cadmium Red Medium, Cadmium Yellow Medium, Cerulean Blue, Dioxazine Purple, Hooker's Green Deep (if you can't find this exact shade, just add black to your Hooker's Green), Payne's Gray, Ultramarine Blue, Vivid Lime Green, Yellow Ochre

Mediums Clearblend, Slowblend (½ teaspoon per cup of water in your water container), Whiteblend

Brushes 2-inch (5cm) bristle flat, nos. 6 and 12 bristle flats, no. 2 filbert, no. 2 bristle fan, no. 4 detail flat, no. 0 liner

Pattern Enlarge the pattern (page 103) 200%

Other large water container, stylus, 14" x 18" (35cm x 45cm) primed and stretched canvas, natural sponge, palette knife, hair dryer, wet palette system, easel, small container for the medium, paper towels, tape, stylus, graphite paper

Color Mixtures

Before you begin, prepare these color mixtures on your palette.

Dark Brown	2 Burnt Umber + 1 Payne's Gray + Dioxazine Purple
Dusty Dark Green	Hooker's Green Deep + Burnt Umber + Burnt Sienna + a touch Dioxazine Purple + a speck Whiteblend
Leaf Green	3 Vivid Lime Green + 1 Hooker's Green Deep + 1 Yellow Ochre + 1 Whiteblend
Dusty Leaf Green	2 Leaf Green mixture + 1 Violet-Gray mixture
Light Yellow-Green	2 Whiteblend + 1 Yellow Ochre + 1 Vivid Lime Green
Dusty Yellow-Green	2 Light Yellow-Green mixture + 1 Violet-Gray mixture
Medium Turquoise	3 Cerulean Blue Hue + 1 Hooker's Green Deep + 3 Whiteblend
Pale Peach	2 Cadmium Red Medium + 1 Yellow Ochre + 100 Whiteblend
Deep Peach	Pale Peach mixture + Cadmium Red Medium + Cadmium Yellow Medium
Dusty Peach	1 Burnt Umber + 1 Pale Peach mixture + Whiteblend
Peach Mist	5 Clearblend + 1 Pale Peach mixture
Violet-Gray	2 Ultramarine Blue + 1 Burnt Sienna + Dioxazine Purple + Whiteblend

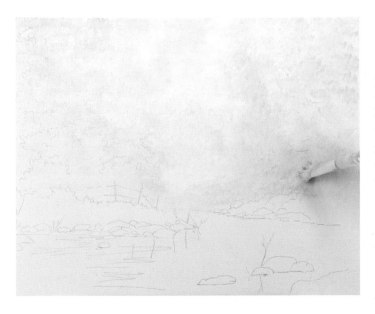

1 Transfer the Pattern and Paint the Sky and Distant Trees

Roughly basecoat your canvas with the pale peach mixture. Make sure to reserve some of the basecoat mix for touch-ups. When the paint is dry, transfer the pattern over it. Paint the sky using your 2-inch (5cm) bristle flat with a variety of values of peach, starting with a slightly deeper brush-mixed peach than the basecoating in the top central area. Add pale peach to your brush as you move lower down the canvas, making the sky progressively lighter. Paint the sky quickly to allow time to apply the distant trees over the wet basecoat. Should your pale peach appear too bright, brush-mix Whiteblend into the paint. Add violet-gray to the uncleaned 2-inch (5cm) bristle flat and stipple in the distant trees over the wet basecoating randomly and quickly. Don't create any particular form or shape to this most distant tree area, just leaf texture.

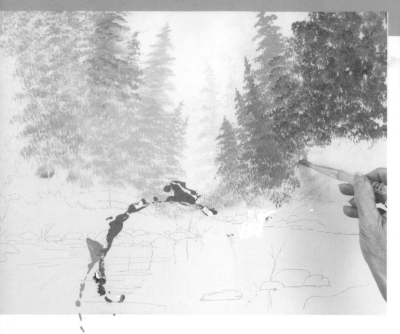

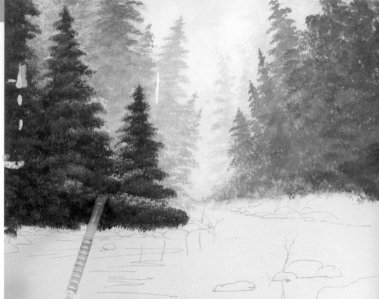

2 Define the Background and Middle Ground Trees

Tap in some more-defined distant trees using your no. 2 filbert with violet-gray. Brush-mix a light green-gray using violet-gray and a speck of dusty dark green with the uncleaned brush and begin adding the middleground trees on both sides of the river with the same tapping stroke. After they dry, tap a light layer of peach mist over these trees to make them recede even further.

The trees need to become progressively darker as they move toward the foreground. Add more of the dusty leaf green incrementally to the no. 2 filbert to make darker trees. Make realistic trees by adding different amounts of each component to your mixtures, ensuring the trees will all be slightly different colors. Switch to a no. 6 bristle flat to block in the lower foliage more quickly. Double load it with dusty leaf green and crunch in some highlights, then load again with dusty yellow-green and add some more.

3 Add the Mist, Foreground Trees and Grass

Brush-mix three parts Clearblend to one part of the basecoat with your no. 12 bristle flat and lightly paint a foggy, sunlit mist over all the background trees.

Add the foreground trees using a no. 2 filbert bristle for the tops and limb tips, a no. 6 bristle flat for the large central mass of foliage, and a no. 2 fan for the grass. Paint all with dusty dark green. Highlight the center tree and the short tree in the foreground using your no. 6 bristle flat double loaded with dusty leaf green on bottom and leaf green on top. Crunch upward with the brush and apply the highlights to only the tips of the limbs, defining the limbs and leaves. Leave spaces between the crunched limb highlights on the central area of the tree, creating a shadow area between limbs.

Double load the top of the uncleaned no. 6 bristle flat with light yellow-green and crunch it on the tops of the limbs on each side of the center foreground tree. Using the same colors on a no. 2 filbert, highlight the left side of short tree to the right of the center tree. Rinse the brush and double load it with dusty dark green on bottom and medium turquoise on top and crunch leaves and limbs into the dark areas of all the foreground trees.

Using a no. 2 bristle fan double loaded with dusty dark green on bottom and medium turquoise on top, crunch and stipple reflected light into the grassy area on the far left side of the canvas. Add leaf green to the brush and highlight the central portion and top right side of the grass. Add light yellow-green to the top side of the fan and stipple it onto the crest of the grass in front of the short tree. Scumble dark brown over the rocks and riverbank, randomly scrubbing the color up into the edges of the grass for shadow.

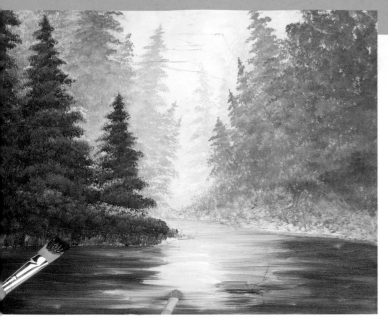

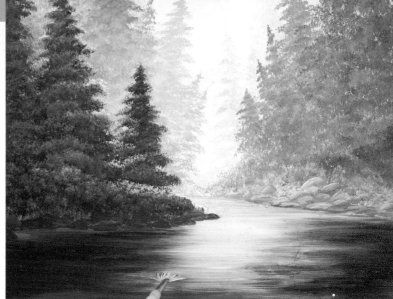

4 Lay in the Water

Work quickly when applying paint to the water area, saving time to blend to its finished appearance before it starts drying and getting sticky; or, work one side of the canvas at a time, drying after one side is complete, remoistening the water area on the other side, adding Clearblend, then color, then blending. Paint the water as follows:

Dampen the entire water area of the canvas with a moist sponge and quickly spread Clearblend over it with no. 12 bristle flat. Add the tree reflections in the wet Clearblend directly beneath each tree using the no. 12 bristle flat and each respective tree's color. Use horizontal, zigzag strokes that move downward from the river bank. Begin with violet gray, then add dusty leaf green, making progressively darker values with dusty dark green at both sides of the canvas. Randomly add little touches of Ultramarine Blue to any or all of the colors in the brush as you go.

Brush-mix and apply horizontal dashes of pale peach (matching the color in the top of the sky) in the central part of the water using your no. 6 bristle flat. Blend the water with a no. 2 fan held horizontally, using horizontal strokes. Lightly stroke a touch of pale peach over the tree reflections on the right and left, and lightly stroke a touch of the tree reflection colors from each side over the pale peach, cleaning the brush on a paper towel between each stroke to avoid muddying the colors.

5 Finish the Water and Add Distant Rocks

If the water area begins to dry and get sticky, stop and dry the painting thoroughly then remoisten it by re-applying Clearblend. Add any color that's lacking, and then blend with a clean, Clearblend-moistened brush following the instructions in step 4. Generally, it takes more than one application of color to reach your desired level of satisfaction in some parts, if not all, of the water.

Block in dull, medium-value rocks on the right river bank with a no. 4 detail flat using brush-mixed violet gray and a touch of dark brown, adding slightly more of the dark brown. Make the shapes larger as they come forward. Block in the foreground rocks and those on the left river bank, as well as their reflections, using dark brown with a tiny touch of violet-gray added in the same manner and with the same brush. Blot the lower portion of the wet reflections to subdue them and submerse them into the water. Dry.

Throughout the painting, paint one rock at a time and blend each before it dries. Highlight the top left sides of the rocks on the right river bank with a no. 4 synthetic detail flat, using brush-mixed dusty peach with a touch of violet-gray. Blend the inside edge of the highlight with a no. 0 liner brush moistened with Clearblend. Blot to subdue if the highlights are too bold.

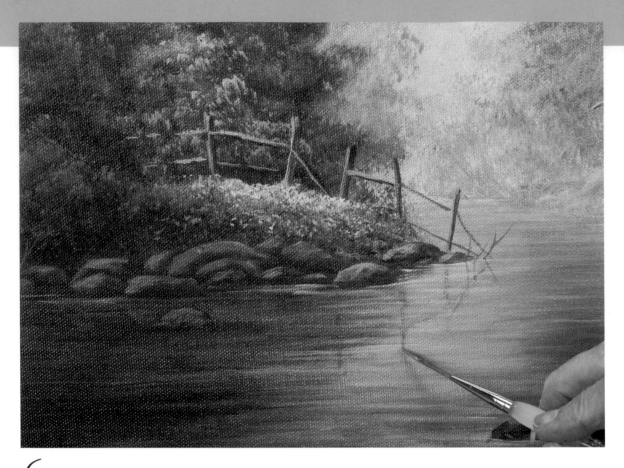

6 *Highlight the Rocks and Add the Fence and Flowers*

Highlight the rocks on the left riverbank with dusty peach using the no. 4 synthetic flat. Blend the inside edges of the highlight using the liner brush moistened with Clearblend. Add more dark brown to the dusty peach mixture to create ridges, form and shapes to the rocks in their shadowy areas, blending as before. Tone the violet-gray mixture with the dark brown and apply reflected light to the right side of the rocks with the same no. 4 detail flat and blend the inside edge with your liner and Clearblend.

Paint the fence using the liner and dark brown. Highlight the top and left sides of the posts and rails with a clean liner brush and deep peach. Moisten the water underneath the fence with Clearblend using a no. 12 bristle flat. Paint the fence's reflection using a no. 0 liner with brush-mixed dark brown and violet-gray. Draw horizontal, perfectly flat water ripples in the dark areas between the rocks and the water using a liner brush and a thinned mixture of Whiteblend and Ultramarine Blue. Add more Whiteblend for the ripples crossing over the fence reflections, and blend the ends of the ripples outward with a Clearblend-moistened comb.

Brush-mix Whiteblend and Dioxazine Purple, Whiteblend and Ultramarine Blue and Whiteblend and Cadmium Red Medium separately for the tiny flowers between the grass and rocks using a no. 2 fan. Brush-mix Whiteblend and light yellow-green into a clean no. 2 fan and stipple this lighter value on the crest of and in the center of the previously highlighted grass at the base of the fence, creating a brightly lit spot of sun. Blot the bottom of the wet paint to blend.

7 Paint the Birds

Apply the birds with the no. 0 liner double loaded with dark brown and pale peach, making the foremost two slightly bigger. Paint their heads with a freshly loaded liner brush. Add tiny beaks on the two foremost, larger birds with brush-mixed Yellow Ochre and Whiteblend. Let it dry thoroughly, then brush-mix Clearblend and Yellow Ochre into your liner and apply dashes of sunlight on the tops of the birds' highlighted wings.

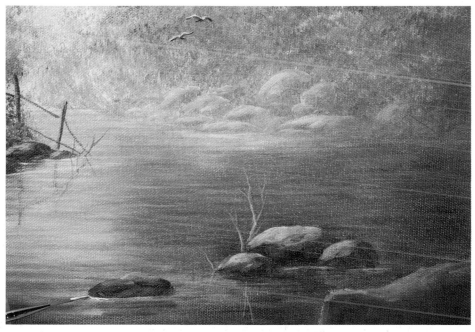

8 Add the Finishing Touches

Moisten with Clearblend, then add additional highlights to a few rocks along the left bank and in the river using brush-mixed peach mist and pale peach and a no. 4 synthetic flat. Soften the edges with the no. 0 liner moistened with Clearblend. Draw some twigs growing around the rocks in the river with a no. 0 liner double loaded with dark brown and pale peach, and draw a squiggly distorted reflection of each twig in the water. Blot the wet reflections.

Remoisten the area with Clearblend and draw water ripples around the rocks in the river, using light peach for the ripples on the left and violet-gray for those in shadow on the right. Place a few Whiteblend ripples in the light peach water area with the same no. 12 bristle flat. Blend the ends of the water lines horizontally outward with a Clearblend-moistened comb. Sign, dry and spray your finished painting with a clear acrylic varnish. Sit back and leisurely enjoy your *Lazy River*.

Seaside Gallery

For an artist, it would be a dream come true to own a quaint gallery by the sea, one so close to home that you could ride your bike to work each day. What a lifestyle!

In real life, most of us will never experience that luxury. However, armed with the desire to be creative, the techniques described here and a few paints and brushes, you can become the master of your dreams. Create the landscape of your imagination!

Visualize the billowing clouds, the balmy breeze rustling the trees and filling the air with the aroma of flowers, and the sounds of the sea as you paint your *Seaside Gallery*.

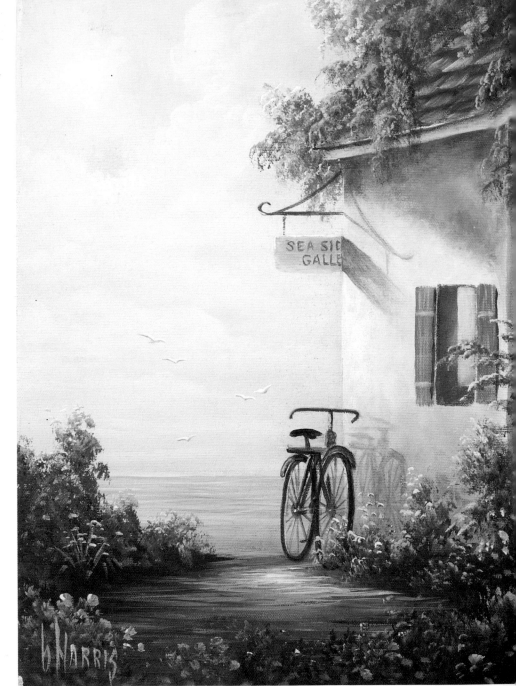

Seaside Gallery
12" x 16" (30cm x 76cm)

Materials

Acrylic Colors Burnt Sienna, Cadmium Red Medium, Cerulean Blue, Dioxazine Purple, Hooker's Green Deep (if you can't find this exact shade, just add black to your Hooker's Green), Payne's Gray, Ultramarine Blue, Vivid Lime Green (Thalo Yellow Green), Yellow Ochre, Yellow Oxide

Mediums Clearblend, Slowblend (add ½ teaspoon per cup of water in your water container), Whiteblend

Brushes 2-inch (5cm) bristle flat, ¾-inch (19mm) mop, no. 0 liner, ⅜-inch (10mm) angle, nos. 2, 4, 6 and 12 bristle flats, nos. 2 and 12 rounds, no. 4 synthetic flat, ½-inch (12mm) comb

Pattern Enlarge the pattern (page 104) 182%

Other wet palette system, large water container, graphite paper, stylus, 12" x 16" (30cm x 76cm) stretched canvas, small disposable cups for mediums, paper towels, palette knife, natural sponge, masking tape, acrylic varnish, hair dryer, easel, small container for the medium

Color Mixtures

Before you begin, prepare these color mixtures on your palette.

Blue-Green	3 Whiteblend + 3 Cerulean Blue + 1 Hooker's Green Deep
Bright Yellow-Green	1 Whiteblend + 1 Light Yellow-Green
Dark Terra Cotta	4 Burnt Sienna + 1 Dioxazine Purple
Light Terra Cotta	1 Burnt Sienna + 1 dark terra cotta + 1 Whiteblend
Wheat	Whiteblend + Yellow Ochre + a touch of light terra cotta
Deep Violet-Gray	3 Whiteblend + 2 Ultramarine Blue + 1 Cadmium Red Medium
Light Violet-Gray	6 Whiteblend + 1 deep violet-gray
Medium Violet-Gray	3 Whiteblend + 1 deep violet-gray
Light and Medium Peach	Whiteblend + Cadmium Red Medium + Yellow Ochre
Medium Leaf Green	2 Whiteblend + 1 Cerulean Blue + 1 Vivid Lime Green
Light Yellow-Green	Whiteblend + 1 medium leaf green + 1 Yellow Oxide
Off-White	Whiteblend + 1 Yellow Oxide
Pink	Whiteblend + a touch of Cadmium Red Medium
Sky Blue	Whiteblend + Cerulean Blue + Ultramarine Blue
Medium Blue	1 sky blue + 1 Ultramarine Blue

1 *Prepare the Canvas and Block in the Sky*

Trace your pattern—with the exception of the bike, foliage and sign—directly onto the canvas. Apply a strip of masking tape vertically along the left exterior line of the traced building to protect the building while painting the sky.

Paint the top of the sky using the 2-inch (5cm) bristle flat with the sky blue mixture. Add more Whiteblend as you move down the canvas, making the sky progressively lighter toward the horizon. Add irregular, horizontal streaks of Whiteblend and lightened sky blue in the bottom third of the sky with your no. 6 bristle flat, making them progressively closer together at the horizon.

Add the cloud shadows using your no. 12 round with the light violet-gray mixture in random, somewhat circular strokes. Make the cloud formations progressively smaller toward the horizon. Blend the shadows into the sky using a dry ¾-inch (10mm) mop.

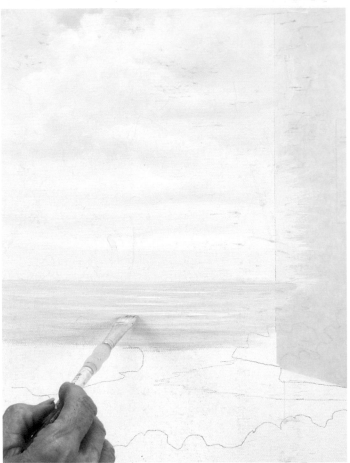

2 *Paint the Sky in the Window and Highlight the Clouds*

Paint the sky showing through the open window using a no. 4 bristle flat with the sky blue mixture. Wait until the sky has dried, then begin highlighting the clouds one at a time, blending each cloud while still wet. Fully load your no. 12 round with Clearblend, and blot the excess on a paper towel. Load the tip of one side of the brush with your off-white mixture. Lay the off-white side of the brush flat against the canvas slightly above the top left side of a cloud shadow, so that both the heel of the brush with Clearblend and the side tip of the brush with off-white touch the canvas. Create off-white billows that connect the cloud shadows using erratic, somewhat circular strokes. Blend the inside edge of the highlight gradually inward with a no. 6 bristle flat moistened with Clearblend. Repeat for all the clouds, making and leaving the outer edges irregular in shape, with larger clouds in the top of the sky and progressively smaller clouds toward the horizon.

3 *Add the Water*

Paint the water wet-into-wet with the medium blue mixture using a no. 2 bristle flat. Keep your strokes horizontal. Add a few streaks of reflected light in the wet paint with your ½-inch (12mm) comb, alternating between the light violet gray and sky blue. Add a few ripples across the water using a clean ½-inch (12mm) comb with Whiteblend and off-white. Blend just the bottom and outer edges of the ripples into the water using a clean comb brush.

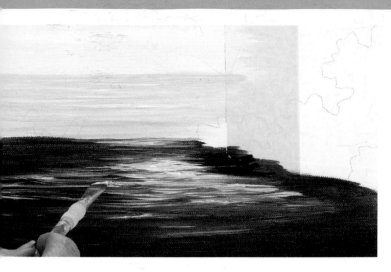

4 Paint the Ground

Use horizontal strokes when painting, highlighting and blending the ground. Paint the central area with light terra cotta using a no. 12 bristle flat. Add dark terra cotta to the brush and paint the rest of the ground, adding Payne's Gray with the same brush to create darker shadows under the shrubbery. Blend slightly where the colors overlap using a ½-inch (12mm) comb. Add random dashes of reflected light with the comb, alternating between medium blue and light violet-gray. Highlight the light terra cotta with a clean ½-inch (12mm) comb using choppy, horizontal streaks of pink, then off-white, concentrating the lightest highlights in the center.

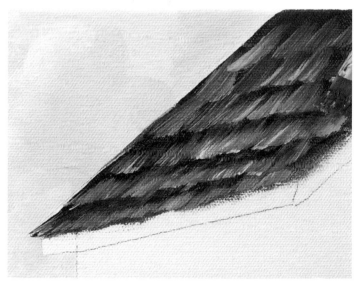

5 Create the Roof

Remove the masking tape from the edge of the building and paint the roof in dark terra cotta using the ⅜-inch (10mm) angle, following the slant of the roof. Create the appearance of shingles using your no. 6 bristle flat and light terra cotta in short, upward strokes that follow the slant of the roof. Apply more pressure at the bottom of the stroke for a darker application, and release the pressure as you move up. Begin each new stroke slightly overlapping the previous one, making them appear stacked. Dry thoroughly. Moisten the roof with Clearblend using your ½-inch (12mm) comb and touch up as needed, adding more highlights with the light terra cotta or shadows with the dark terra cotta.

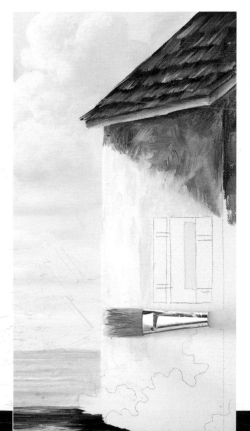

6 Begin the Building

Using your no. 4 synthetic detail flat, apply deep violet-gray to the top of the wall just underneath the fascia moulding and add light violet-gray as you move down the wall. Blend the colors together with a clean ½-inch (12mm) comb. Add hints of sky blue for color variety, and control the value of the colors by adding Whiteblend as you paint. Paint the sunlit portion of the building off-white with intermittent dashes of light peach and pink using your no. 6 bristle flat. Lay the brush sideways and paint the edges of the building to get a smooth line. Add dashes of Whiteblend sporadically in the most sunlit areas of the building. Blend where the building and shadow colors merge with a clean, towel-dried ½-inch (12mm) comb, then smooth with a ¾-inch (19mm) mop. Continue to the next step before the paint dries.

7 Finish the Building

Add off-white with intermittent dashes of light peach and pink angling across the house underneath the window so that it overlaps and blends into the already painted area. Apply the light violet-gray shadow along the base of the house, below the window, with your ⅜-inch (10mm) angle. It should overlap slightly into the bottom of the off-white above . Blend with a clean, towel-dried ½-inch (12mm) comb, then smooth with a ¾-inch (19mm) mop.

Paint the back side of the house using your no. 6 bristle flat with different values of the violet-gray and intermittent touches of light Cerulean and medium blue. Add darker values at the top and bottom and lighter values in the central portion, retaining some color contrast at the edge to distinguish the side of the house from the front. Tidy up the building's corners using the chisel edge of a ½-inch (12mm) comb. Blend and smooth as before and allow the paint to dry thoroughly.

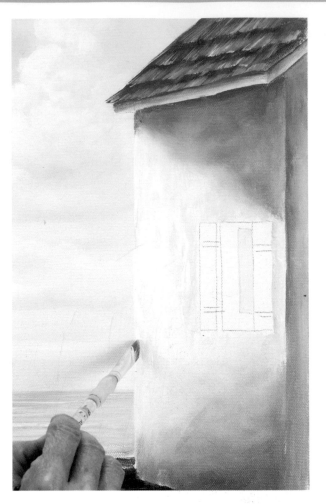

8 Add the Window Details

Paint the shadow inside of the window with the light and dark violet-gray using your no. 4 synthetic flat. Clean the no. 4 flat and use it to paint the shutters light terra cotta. Draw dark terra cotta and off-white wood-grain streaks vertically through the shutter with the no. 0 liner while the paint is still wet. Draw horizontal moldings on the shutters with a brush-mixture of light terra cotta and off-white on the no. 0 liner. Paint the right edge of the shutters with the no. 0 liner using diluted dark terra cotta. Dry thoroughly.

9 Paint the Bike

Trace the sign, bicycle and foliage onto the canvas. As you paint, clean up any wobbly lines as they occur with a clean no. 4 synthetic flat. Paint the tires, sprockets, pedals, handlebars and seat of the bike using a no. 0 liner with a mixture of Payne's Gray, water and a touch of Slowblend. Use diluted paint and put minimal pressure on the brush to create these thin lines. Highlight the bike with brush-mixed Payne's Gray and Whiteblend using a no. 0 liner. Add the spokes with the same brush using a slightly darker mixture of Payne's Gray and Whiteblend.

Paint the fenders and frame of the bike with a creamy mixture of Cadmium Red Medium and water using the liner brush. Brush-mix Payne's Gray into the Cadmium Red Medium on your liner and add shadows to the fenders and frame. Rinse the liner and highlight the fenders and frame with brush-mixed Cadmium Red Medium and Whiteblend. Age a few places on the bike with small streaks and dashes of translucent, brush-mixed Payne's Gray, Whiteblend and Clearblend using a no. 0 liner. Blot to subdue the "aging" paint if it is too opaque.

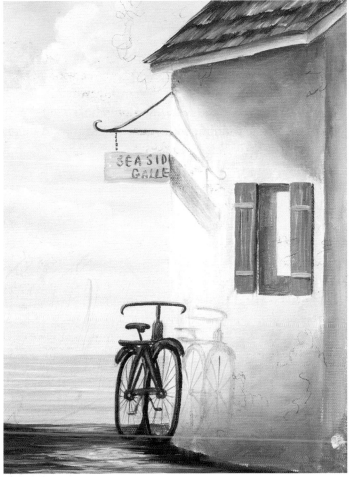

10 Paint the Sign and Shadows

Paint the sign with the wheat mixture using either a no. 4 synthetic detail flat or a ⅜-inch (10mm) angle. Write the lettering with the no. 0 liner using a diluted brush-mixture of dark terra cotta, Slowblend and water. Change the name of the gallery if you'd like—whatever is special to you!

Moisten the shadowed area with Clearblend and a touch of Slowblend using your no. 6 bristle flat. Add shadows from the sign and the bike wet-into-wet with a translucent mixture of Clearblend and medium and light violet-gray using the no. 0 liner. Use the ⅜-inch (10mm) angle for the sign's shadow.

11 Add Foliage to the Roof and Ground

Stipple foliage onto the roof and ground using a no. 6 bristle flat with Hooker's Green Deep. While the ground foliage is wet, soften the bottom of the foliage onto the dirt using a wet ½-inch (12mm) comb moistened with Clearblend.

Double load your no. 6 bristle flat with Hooker's Green Deep and blue-green, then stipple, crunch and tap reflected light and highlights onto the foliage. Add medium leaf green to the blue-green side of the brush and repeat, applying highlight on and around the top left-hand foliage clusters. Randomly blot to subdue the highlight in the innermost areas of the foliage. Add light yellow-green to the highlight side of the uncleaned brush and stipple and tap along the outside edges of the tree. Blot to subdue, then add bright yellow-green to the brush and tap sparse dabbles of this highlight along the top right side of some foliage near the sign, the wheel of the bike and along the top of the foliage on the left. Extend a few taps into the top of the foliage in those areas. Do not apply to all areas of the foliage and blot as before.

12 Paint the Most Sunlit Flowers

Add the small, bright flowers in the sunlit area of the foliage at the base of the house. Be sure to space and shape them irregularly for a natural look. Create hot pink flowers with your no. 0 liner using marbleized Cadmium Red Medium and Whiteblend, with additional Whiteblend on the top of the brush for the highlight. Add a few Dioxazine Purple and Whiteblend flowers and Ultramarine Blue and Whiteblend flowers in the same manner in the more shadowed areas of this same foliage.

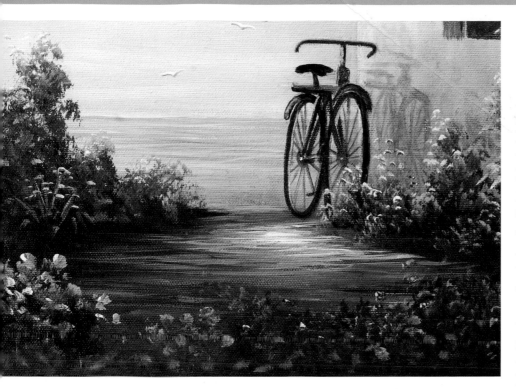

13 Detail and Add Flowers to the Foreground Foliage

Add a few larger and more defined leaves in the foremost foliage using the no. 2 round double loaded with Hooker's Green Deep and blue-green. Create the blue flowers with a clean liner and a marbelized mixture of Ultramarine Blue and Whiteblend. Add stems and leaves for the flowers using a no. 0 liner using leaf green and light yellow-green.

Rinse your liner, then use it to tap tiny flowers into the foliage using mixtures of Whiteblend with each of the following colors: Ultramarine Blue, Dioxazine Purple, Cadmium Red Medium, medium peach and wheat. Tap larger, Impressionistic flowers into the foreground with a no. 4 synthetic detail flat double loaded with light violet-gray on the bottom and a variety of the flower colors on top.

14 Add Finishing Touches and Birds

To tidy up or embellish any area, moisten the area with Clearblend and add additional color wet-into-wet, then blend. When you're satisfied, add small gulls using a no. 0 liner double loaded with light violet-gray mixed with a touch of Slowblend and Whiteblend for the highlight. Sign your name artistically and let the painting dry, then spray it with a clear acrylic aerosol varnish. Choose a frame that accentuates the beauty of your *Seaside Gallery* and display it prominently!

Stone Ground

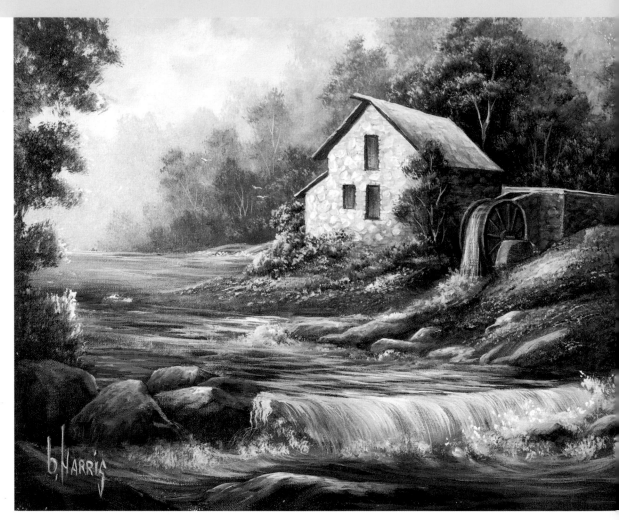

Stone Ground
12" x 16"
(30cm x 41cm)

For many decades, the gristmill was a focal point of vital, thriving industry. However, most mills have been pushed aside for the more efficient but less charming vehicles of modern technology. A prime example of a typical eighteenth century corn and wheat gristmill that's still operational is the Wayside Inn Grist Mill in South Sudbury, Massachusetts, which was my inspiration in creating this painting. Its water wheel powers two running millstones and a complex elevator system that was typically used in mills in the 1700s.

The mill was restored by Henry Ford in 1929 and still grinds wheat and corn today. It makes unbleached flour and cereal, which is used in the Inn's food service and sold to interested visitors. The Wayside Grist Mill is open from April through November, with historic milling demonstrations taking place on weekends.

As an artist, I have taken some liberties designing how I think these mills might have looked in their prime. Gristmills are interesting places to visit and fun subjects to paint. So let's get grinding! I hope you enjoy it.

Materials

Acrylic Colors Burnt Sienna, Burnt Umber, Cadmium Red Medium, Cadmium Yellow Medium, Cerulean Blue Hue, Dioxazine Purple, Hooker's Green Deep (if you can't find this exact shade, just add black to your Hooker's Green), Payne's Gray, Ultramarine Blue, Vivid Lime Green (Thalo Yellow Green)

Mediums Clearblend, Slowblend (add ½ teaspoon per each cup of water in your water container), Whiteblend

Brushes nos. 2 and 6 bristle flat, no. 0 liner, ½-inch (12mm) comb, ½-inch (12mm) mop, no. 2 bristle fan, ⅜-inch (10mm) angle, no. 4 synthetic flat

Pattern Enlarge the pattern (page 105) 192%

Other 12" x 16" (30cm x 41cm) canvas, palette knife, natural sponge, large water container, palette, paper towels, adhesive design protector, acrylic varnish, hair dryer, small container for the medium, tape, stylus, graphite paper

Color Mixtures

Before you begin, prepare these color mixtures on your palette.

Bright Yellow-Green	Vivid Lime Green + Whiteblend + a touch of Cadmium Yellow Medium
Cocoa	2 Burnt Sienna + 1 Dioxazine Purple + 1 White-blend
Taupe	Cocoa + a touch of Payne's Gray + Whiteblend
Dark Brown	3 Burnt Umber + 1 Dioxazine Purple
Dark Green	Hooker's Green Deep + Burnt Umber + Burnt Sienna
Dusty Teal	3 Cerulean Blue Hue + 1 dark green + White-blend
Light Peach	Whiteblend + medium peach
Light Turquoise	1 Vivid Lime Green + 1 Cerulean Blue Hue + Whiteblend
Mauve	Cadmium Red Medium + Dioxazine Purple + Burnt Sienna + Whiteblend
Light Gray-Green	2 mauve + 1 Hooker's Green Deep + 4 Whiteblend
Medium Gray-Green	Add a touch more Hooker's Green Deep to the light gray-green
Light Yellowish Gray-Green	3 Whiteblend + 2 light gray-green + 1 Vivid Lime Green
Medium Yellowish Gray-Green	4 Whiteblend + 2 Vivid Lime Green + 1 light gray-green
Medium Peach	Cadmium Red Medium + Cadmium Yellow Medium + Whiteblend
Navy	2 Ultramarine Blue + 1 Payne's Gray
Sky Blue	Ultramarine Blue + Whiteblend

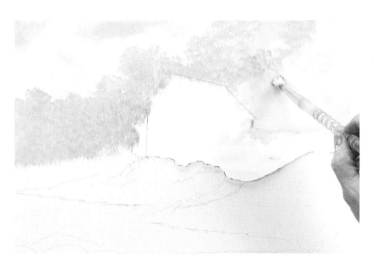

1 *Paint the Sky and Distant Trees*

Trace the pattern onto the canvas and place an adhesive design protector over the mill. Using your no. 6 bristle flat and the sky blue mixture, paint a sky in irregularly shaped strokes that becomes progressively lighter toward the horizon. Add Whiteblend to the uncleaned brush and create soft cloud shapes, making them lighter in the lower part of the sky. Blend slightly with your ½-inch (12mm) mop, creating a blustery sky.

Add a touch of mauve to your uncleaned no. 6 bristle flat and stipple the most distant trees over the wet sky. Make the trees darker and more vibrant as you move to the right by incrementally adding more mauve to the brush. Add a speck of Payne's Gray to create shadows in the lower portions of some of the trees.

2 *Paint the Middle Ground Trees*

Stipple progressively darker rows of green trees behind the gristmill with the no. 6 bristle flat, working left to right. Begin with the light gray-green mixture for the most distant of these green trees, adding the medium gray-green toward the middle and dark green closest to the gristmill. Occasionally vary the values in the top areas of the trees by adding a touch of sky blue mixture to each respective color.

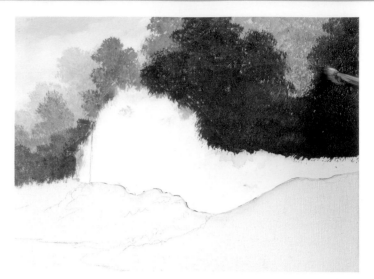

3 *Add Tree Limbs, Highlights and Reflected Light*

Brush-mix the cocoa and light peach mixtures with your no. 0 liner, creating a light tan color, and use it to add the tree trunks and limbs. Blot the bases of the tree trunks with your finger to recede them into the foliage.

Stipple reflected light randomly into the darker trees using your no. 6 bristle flat double loaded with dusty teal on top and dark green on bottom. Highlight the distant trees using a no. 2 bristle flat double loaded with light gray-green on bottom and light yellowish gray-green on top. Stipple the highlight on the top left outside edges, as well as in small clusters on the right sides of the trees. Blot the bottom portion of the highlights to create a gradual color transition and recede it into shadow. Highlight the middle ground trees in the same manner, using the no. 2 bristle flat double loaded with light yellowish gray-green on top and medium gray-green on bottom. Highlight the trees behind the grist mill using a no. 6 bristle flat double loaded with medium yellowish gray-green on top and dark green on bottom. Blot as needed.

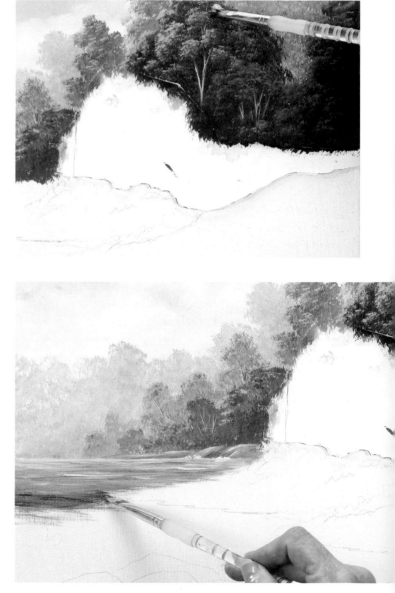

4 *Begin the Water*

Using your ½-inch (12mm) comb, apply the distant riverbank with the cocoa mixture in horizontal strokes. Add a little of the medium peach to the top of the uncleaned comb and highlight the bank.

Rinse your ½-inch (12mm) comb and block in the distant water using the sky blue mixture. With the same brush, randomly add horizontal streaks of the navy mixture and a touch of mauve in the distant water. Paint water spilling over the distant riverbank and some splashes where it hits the bank with Whiteblend and a clean ½-inch (12mm) comb. Add additional ripples in the distant water with horizontal strokes of Whiteblend applied with the same brush.

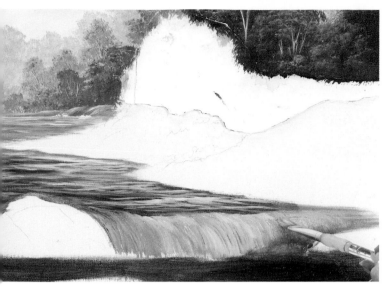

5 *Add the Rest of the Water*

Work on the water one section at a time, being sure to connect each section to the one before it to create a gradual, flowing transition from the light values in the background to the darks in the foreground. Block in the middle section of the water using the sky blue mixture, Ultramarine Blue, navy and an occasional dash of mauve with your no. 6 bristle flat in sweeping horizontal strokes. Add detail and patterns to the water with your ½-inch (12mm) comb using various values of blue created by separately brush-mixing Whiteblend into light turquoise, sky blue and Cerulean Blue. Add horizontal water ripples with a cleaned comb and Whiteblend. The water should get progressively darker as it moves toward the foreground.

Use curving, downward strokes to paint the waterfall with your ½-inch (12mm) comb and the light turquoise mixture. With the same brush, darken the outer portion of the waterfall on the left, putting it into shadow by adding color from the middleground water. Brush-mix Ultramarine Blue, Cerulean Blue and Whiteblend into a clean ½-inch (12mm) comb and sparingly add a few darker streaks throughout the waterfall.

6 *Begin Painting the Mill*

Remove the adhesive design protector from the mill and paint the roof with your ⅜-inch (10mm) angle brush, placing medium peach in the top section, cocoa in the bottom left, and taupe in the bottom right, overlapping the edges of the colors. Blend where the colors overlap. Follow the slant of the roof and leave streaks in the paint to resemble shingles. Add more shingle marks as needed with your no. 4 synthetic flat, using a slightly lighter shade of that part of the roof.

Use your no. 4 synthetic flat to paint dark brown inside the windows with a vertical, downward stroke. When the windows are dry, brush-mix sky blue and Clearblend on a clean no. 4 synthetic flat and stroke upward from the bottom of the window, putting a shimmer of reflected light over the windows that dissipates as it moves upward.

Draw a shadow line indicating the recessed portion on the top and left of each window using a thinned brush-mixture of dark brown and Payne's Gray on your no. 0 liner. Paint the eaves dark brown with your no. 0 liner. Highlight the top edge of the eaves with a clean no. 0 liner brush and light peach. Roughly block in the mottled shadowy areas on the side of the building, wheel and reservoir using your ⅜-inch (10mm) angle with dark brown.

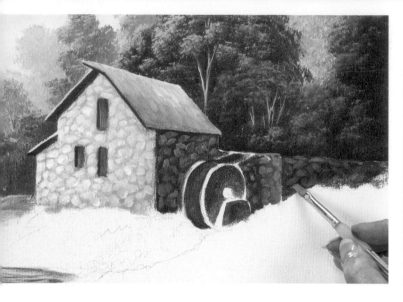

7 Detail the Mill

Brush-mix mauve and a touch of Payne's Gray and apply it over the front of the building alternating between your ⅜-inch (10mm) angle and no. 4 synthetic detail flat. Vary the values, sometimes using more mauve, sometimes more Payne's Gray. Darken this mixture slightly and use the same brush to paint the side of the building and the wall behind the water wheel.

Add medium peach to the mauve and Payne's Gray mixture and randomly blot different shapes and sizes of stones onto the front of the building with your no. 4 synthetic flat. Rinse your brush and add peach and light peach stones, leaving some of the gray showing to look like mortar.

Paint the stones in shadow on the side of the mill and around the water wheel using a no. 4 synthetic detail flat and beginning with cocoa. Randomly blot to subdue. Tone the taupe mixture with a little Payne's Gray and use it with the no. 4 flat to add more rocks, blotting as before. Add a touch of the dark brown to each mixture and darken the stones if they appear too light to be in shadow.

8 Paint the Water Wheel and Block in the Ground and Rocks

Brush-mix a little Payne's Gray into the dark brown mixture with your no. 0 liner and use it to paint the wheel, its spokes and shadows. Highlight the edge of the wheel with medium and light peach using your liner. Continue to add different values and colors in the details of the wheel using dark brown and dark brown toned with either Payne's Gray or medium peach, always with the liner.

Block in the mottled ground beneath the gristmill with a translucent wash of brush-mixed Burnt Umber, Clearblend and water using your no. 6 bristle flat. Use your brushstrokes to create a contour to the land. Add shadows in the bottom right corner and randomly throughout the wet ground paint, using dark brown and Payne's Gray on the same no. 6 bristle flat.

Block in the rocks at the bottom of the waterfall and on the left side of the water using your ⅜-inch (10mm) angle and no. 4 synthetic flat with dark brown. Add Payne's Gray to the mixture to create and blend their shadows and darken the foremost rocks while they're still wet. Let the paint dry.

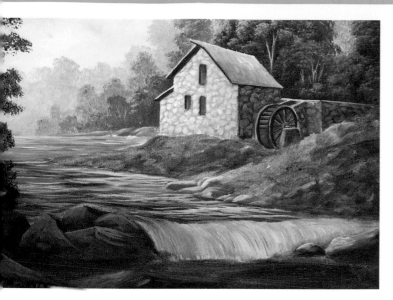

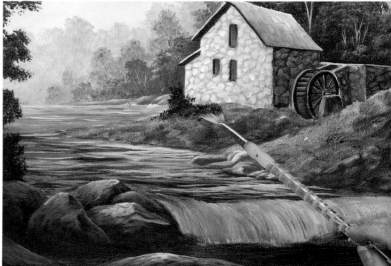

9 Add the Rock Details and Foreground Tree

Use two brushes to add the details to the irregularly shaped rocks: a no. 4 synthetic flat to apply and a ½-inch (12mm) comb to blend. Apply the reflected light and highlights to the rocks with small dabs and squiggly strokes to create a rough texture. Blend the edges of the reflected light and highlight while it's wet with your comb moistened with Clearblend. Vary the amount of highlight and reflected light placed on the rocks so that some rocks are more prominent than others.

Paint the reflected light on the rocks alternating between sky blue and dusty teal, both toned with dark brown. Highlight some rocks with mauve, medium peach and light peach, toning the highlights with dark brown for less sunlit rocks and omitting the highlight for those rocks in shadow. Dry the rocks.

10 Finish the Rocks and Add Foreground Foliage

To brighten the rocks, moisten then with Clearblend and add more highlights wet-into-wet with the no. 4 synthetic flat. Blend while they are still wet with the ½-inch (12mm) comb. To tone down areas on the rocks or accent crevices, use the same brushes for application and blending with brush-mixed dark brown and Clearblend.

Stipple the foreground trees along the left side of the canvas using a no. 6 bristle flat and brush-mixed dark green, Burnt Sienna and a touch of water. Add dark green to the uncleaned brush and stipple all the foliage in front of the gristmill. Use the liner double loaded with dark brown and cocoa to add limbs to the tree at the corner of the building.

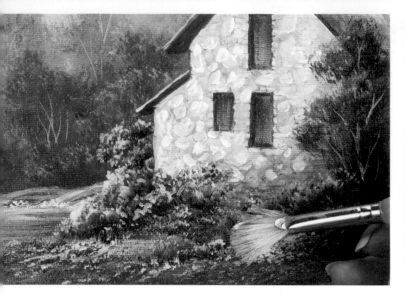
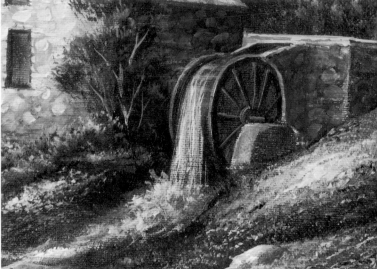

11 *Highlight the Trees and Add Grass and Flowers*

Crunch reflected light into the foreground foliage with a no. 6 bristle flat double loaded with dark green on bottom and dusty teal on top. Rinse the brush and double load it with dark green and Vivid Lime Green, and crunch highlights on the tips of random limbs, using only the corner of the brush. Add bright yellow-green to the top of the brush and tap a few brighter leaves onto the previously highlighted areas of foliage.

Moisten the ground using the no. 2 bristle fan loaded with Clearblend. Stipple the grass randomly over the hillside using the same bristle fan and brush-mixed dark green and Clearblend, tilting the brush to follow the contour of the land underneath. Add dusty teal to the top side of the fan and then lightly and randomly stipple reflected light in the dark green grassy area, tilting the brush as before. Highlight areas in the grass by double loading Vivid Lime Green on the dusty teal side of the fan and lightly tapping the sunlit areas. Sparingly tap light bright yellow-green in the center of the previously highlighted areas with a clean fan brush.

Double load your fan with Ultramarine Blue on bottom and a mixture of Ultramarine Blue and Whiteblend on top and lightly tap blue flowers onto the grass. Blot their bottoms to recede them into the foliage. Rinse the brush and reload it with a medium value of Cadmium Red Medium and Whiteblend in the bottom and a lighter value of Cadmium Red Medium and Whiteblend in the top, then use it to add the pink flowers in front of the gristmill. Blot the bottom of each patch of flower color.

12 *Add the Water Flowing Over the Wheel*

Brush-mix Whiteblend and a touch of navy with your ½-inch (12mm) comb to create a light blue-gray. Apply light blue-gray streaks downward over the wheel, indicating water pouring down to the ground and flowing to the river. Follow the slope of the ground and be careful not to paint a solid line of blue—it should be streaky and random, suggesting movement. Rinse your comb and use it to apply Whiteblend streaks sparsely over the light blue-gray water falling from the wheel. Stipple Whiteblend splashes around the base of the wheel and in the water flowing to the river with the corner of your no. 2 fan. Soften the bottom of the splashes with a clean, moist corner of the no. 2 fan.

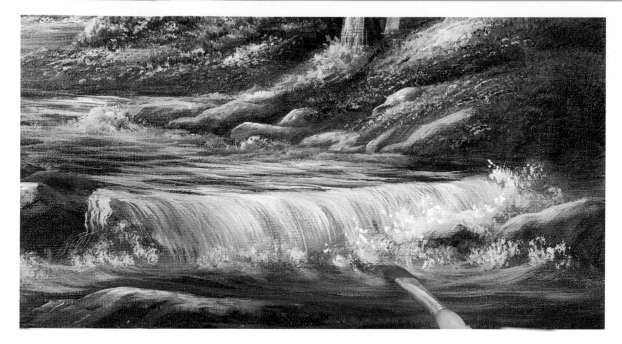

13 Detail the Water and Foreground Waterfall

Moisten the middle ground water with Clearblend using a no. 6 bristle flat. Brush-mix light turquoise, Whiteblend and a touch of navy into your no. 2 fan. Double load the top side of the brush with Whiteblend and crunch a few splashes along the river bank. Add a few splashes of pure light turquoise. Using your ½-inch (12mm) comb moistened with Clearblend, pull from the bottom of the splashes to create short ripples across the river. Add more ripples using the same comb with various values of turquoise, Whiteblend and navy. Blot the bottoms of the ripples with your finger to merge them into the water beneath them. Repeat this process in the foreground water.

Moisten the waterfall with Clearblend using a no. 6 bristle flat. Brush-mix Whiteblend and Ultramarine Blue in your no. 2 fan and apply random streaks over the waterfall. Rinse the brush and apply streaks of Whiteblend.

14 Add the Birds and Finishing Touches

Brush-mix navy, Whiteblend, water and a touch of Slowblend into your no. 0 liner, creating a medium value of gray, then double load it with Whiteblend. Apply tiny flying birds in front of the distant gray-green trees. Keep these small and in perspective with your painting. Sign and dry your painting, then spray it with a clear acrylic varnish.

Seek out historical gristmills on your next travels and use these techniques to paint their likenesses. Enjoy!

Pemaquid Lighthouse

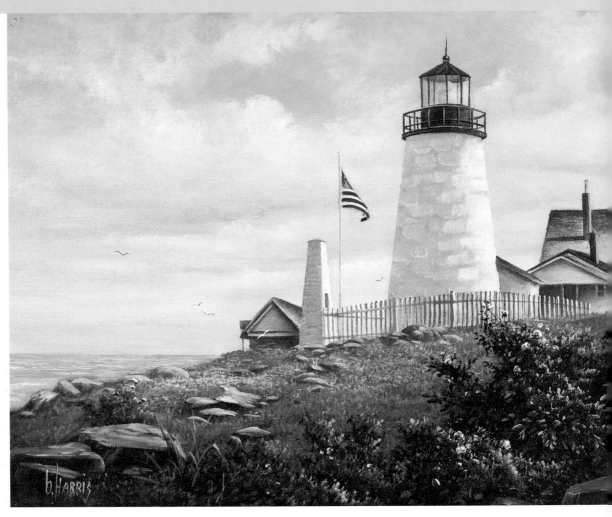

Pemaquid Lighthouse
12" × 16"
(30cm x 41cm)

The Pemaquid Lighthouse perches atop a rocky cliff facing the Atlantic Ocean on the western side of Muscongus Bay, Maine. It was originally built in 1827, was rebuilt in 1857, and is still operational today and open to visitors.

The state of Maine operates the Fisherman's Museum inside the keeper's house, displaying interesting artifacts from Maine lighthouses and the fishing/lobster industry. It's a fun place to visit. Take your camera and allow extra time to visit and shop in the nearby town of Bristol.

Thanks to my friend and Windam, Maine, seminar host Pat Riley for sharing her photos. I used one of her photos as a reference for this composition. Seems her camera has a better eye than mine!

Materials

Acrylic Colors Burnt Sienna, Burnt Umber, Cadmium Red Medium, Cerulean Blue Hue, Dioxazine Purple, Hooker's Green Deep (if you can't find this exact shade, just add black to your Hooker's Green), Payne's Gray, Raw Sienna, Ultramarine Blue, Vivid Lime Green, Yellow Ochre

Mediums Clearblend, Slowblend (½ teaspoon per cup of water in your water container), Whiteblend

Brushes 2-inch (5cm) bristle flat, nos. 2, 4, 6 and 12 bristle flats, no. 0 liner, ⅜-inch (10mm) angle, no. 4 synthetic flat, nos. 2 and 12 rounds, ½-inch (12mm) comb, no. 2 bristle fan, ⅜-inch (10mm) mop, ½-inch angular wisp (optional)

Pattern Enlarge the pattern (page 106) 182%

Other palette knife, natural sponge, palette, 12" × 16" (30cm × 41cm) stretched canvas, easel, small container for the medium, paper towels, tape, stylus, graphite paper

Color Mixtures

Before you begin, prepare these color mixtures on your palette.

Dark Brown	4 Burnt Umber + 2 Payne's Gray + 1 Dioxazine Purple
Brownish Green	1 dark brown mixture + 1 Vivid Lime Green + Raw Sienna + 2 Yellow Ochre
Deep Teal	3 Cerulean Blue Hue + 2 Whiteblend + 1 Hooker's Green Deep
Dusty Pink	Whiteblend + Cadmium Red Medium + Yellow Ochre + Burnt Sienna
Light Cerulean	1 Cerulean Blue Hue + 4 Whiteblend
Light Violet-Gray	12 Whiteblend + 6 Ultramarine Blue + 1 Dioxazine Purple + a touch Burnt Umber
Light Gray	light violet-gray mixture + Burnt Umber and Whiteblend
Taupe	light violet-gray mixture + dark brown mixture
Medium Sky Blue	6 Ultramarine Blue + 1 Burnt Umber + 10 Whiteblend
Medium Yellow-Green	1 Vivid Lime Green + 1 Burnt Umber + 1 Whiteblend
Off-White	Whiteblend + 1 Yellow Ochre

1 *Trace the Pattern and Lay In the Sky*

When tracing the pattern, you can create the buildings one of two ways. You can trace the buildings before you begin and preserve their white by using a design protector, or you could paint the sky and then reinforce the tracing lines of the building so you can still follow them. I used design protectors.

Block in and blend the sky colors with sweeping horizontal strokes, placing medium sky blue in the top portion of the sky with your 2-inch (5cm) bristle flat, light cerulean at the bottom using the no. 12 bristle flat, and a random blend of those colors through the central area. Make the general value of the sky darker in the top and progressively lighter toward the horizon. Add Whiteblend streaks randomly through the lower sky while it's still wet, creating different values of the light cerulean.

Add Whiteblend to the upper and central area of the wet sky with a no. 6 bristle flat to create a base for the clouds. Apply light violet-gray shadows around and below the cloud base and randomly through the wet sky with the uncleaned no. 12 bristle flat. Blend the sky colors with a clean, dry no. 12 round bristle, using horizontal strokes in the lower portions and erratic, somewhat circular strokes in the top. Use both types of stroke to blend through the central area. Wipe the excess paint from the blending brush frequently for a smoother blend. Complete the final blending with the ⅜-inch (10mm) mop. Dry.

2 *Paint the Clouds*

Work with three different brushes to apply and blend the cloud highlights: a no. 12 round, 2-inch (5cm) bristle flat and no. 2 fan. Prepare the no. 12 round for blending by heavily loading it with Clearblend and blotting the excess onto a paper towel, then set it aside for the moment. Moisten a section of the sky with Clearblend using the 2-inch (5cm) bristle flat. Apply a few dabs of off-white highlight onto the tops of the clouds with the no. 2 fan.

Pick up the prepared no. 12 round and use it to create irregularly shaped billows within the clouds using tapping and swishing motions to randomly distribute the off-white highlights. Leave the off-white thicker in the most luminous parts of the clouds and decreasing in thickness as you move toward the shadowy areas. Add a few more dabs of off-white with the no. 2 fan and repeat, connecting several highlighted areas to create large formations of different shapes and sizes in the top of the sky that become progressively smaller toward the horizon.

3 *Add the Ocean*

Without washing the brush between colors, apply then blend the water area with the ½-inch (12mm) comb, using horizontal streaks of all the sky colors in this order: light violet-gray along the crest of the water at the horizon, keeping it perfectly flat; medium sky blue in the central area; and light cerulean in the foremost water area. Wipe the excess paint from the brush and blend with horizontal strokes to create a gradual transition in colors.

Apply horizontal, choppy ripples and whitecap streaks of Whiteblend randomly throughout the water with your no. 0 liner. Make the distant ripples progressively smaller, closer together and less vibrant than the foreground white-caps. Blend the abrupt endings of the ripples and white-caps and soften their bottoms into the water with a clean, dry ½-inch (12mm) comb.

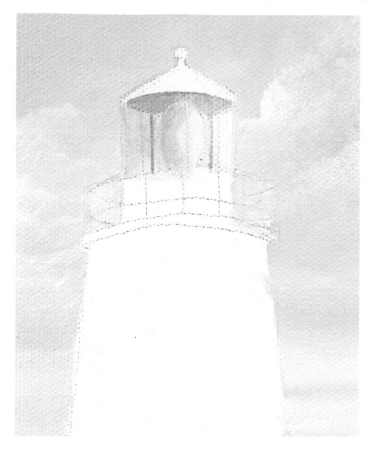

4 Begin the Lighthouse Dome

Remove the adhesive design protector from over the buildings and trace the flag and pole, or if you didn't use a design protector, trace the buildings and flag. If you used a design protector, paint the sky where it will show through the glass top of the lighthouse and between the handrails. Using your no. 4 synthetic flat, apply whatever sky color should appear there.

Clean the no. 4 synthetic flat and use it to paint the lantern bulb underneath the dome, off-white on the right and light violet-gray on the top and left side. Wipe the excess from the brush and blend the colors. Using brush-mixed Payne's Gray and light violet-gray, paint the inside and two backside window moldings with the no. 0 liner. Let it dry thoroughly.

To create the glass over the lantern, mix two parts Clearblend with one part light violet-gray in your ⅜-inch (10mm) angle and glaze it over the left side. Rinse the brush and mix two parts Clearblend with one part Whiteblend and glaze it over the right side. Wipe the angle clean and blend slightly in the center.

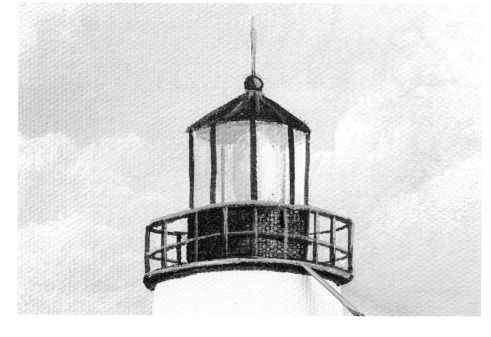

5 Finish the Top of the Lighthouse

Using your no. 4 detail flat, paint the dome of the lighthouse with Payne's Gray. Highlight the top and right side of the dome with the same brush using light gray. Use the no. 0 liner with the same colors to add the ball and antenna at the top. For the base of the dome, use your no. 4 synthetic flat with Payne's Gray. Blot with your finger while the paint is still wet to create a highlight on the right side. Let the paint dry, then use your no. 0 liner to add the lines on the dome and handrail with Payne's Gray. Highlight them with light gray using a clean no. 0 liner on the tops and right sides.

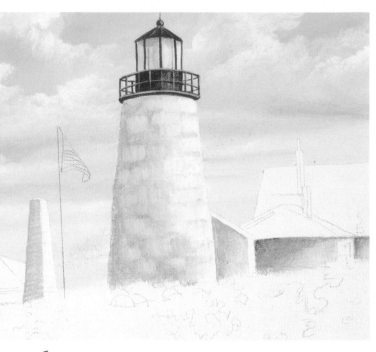

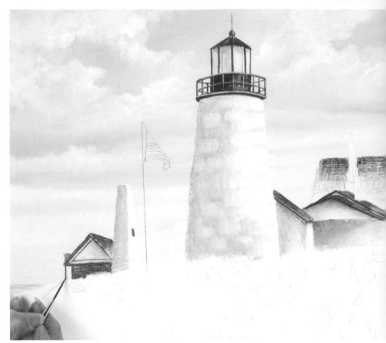

6 Begin the Buildings

Create the appearance of stone on the lighthouse by applying and blending Whiteblend and off-white on the right and light gray and light violet-gray on the left using a ⅜-inch (10mm) angle with choppy strokes. Overlap the colors in the middle of the lighthouse, and wipe the excess paint from the brush between colors and while blending. Accentuate a few mortar joints between stones with the chisel edge of a ½-inch (12mm) comb using brush-mixed off-white and light gray.

Paint the shadow sides of the houses using the no. 4 synthetic flat and alternating between light gray and light violet-gray. With the same brush, paint the lighter side on the right with Whiteblend. Blend the colors with a clean ½-inch (12mm) comb. Add a touch of Payne's Gray with the no. 4 synthetic flat anywhere the shadows need to be deepened.

Paint and add texture to the tower on the left by alternately tapping on light gray, light violet-gray and off-white with a ½-inch (12mm) comb and a no. 4 synthetic flat.

7 Paint the Roofs

Paint the side of the far left house and the darker portions of the shorter house's roofs using various values of brush-mixed Burnt Sienna and light gray. Add off-white in the lighter areas using either the no. 0 liner or the no. 4 synthetic detail flat, depending on the size of that individual roof. Blend the roofs with a clean ½-inch (12mm) comb. Lighten the Burnt Sienna mixture with some off-white and indicate a few bricks on the side of the far left house.

Moisten the tallest roof, on the far right, with Clearblend, using the ⅜-inch (10mm) angle. Brush-mix Payne's Gray and Clearblend with the ½-inch (12mm) comb and tap shingles from the peak of the roof downwards, getting lighter as you go, stopping about halfway down the roof. Rinse the comb and tap in the lower shingles with light cerulean, creating a gradual transition between the colors in the central and lower area of the roof. Leave the texture choppy to give the appearance of shingles.

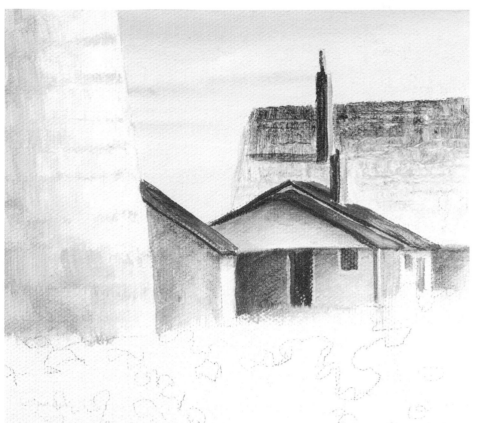

Chimney Detail

8 *Detail the Buildings*

Use a no. 0 liner to paint the left sides of the chimneys with Burnt Sienna and the right sides with a mixture of Burnt Sienna and Whiteblend. Add a shadow at the base of each chimney with a mixture of Payne's Gray, Clearblend and a touch of Dioxazine Purple on your no. 0 liner.

Add the building's windows and doors, as well as the post in front of the foreground building on the right, using your no. 0 liner and a mixture of light violet-gray darkened with a touch of Payne's Gray. Add their off-white moldings with a clean no. 0 liner.

9 Lay In the Hillside

Moisten the hillside with your sponge and apply Clearblend over it with the 2-inch (5cm) bristle flat. Wipe the excess from the brush and add medium yellow-green. Use it to scumble a thin, translucent coating over the top third of the hillside. Add the brownish green mixture to the uncleaned brush for the central area, and dark brown to the same brush for the bottom section. Overlap and blend the colors where they join. Wipe the excess paint from the brush and use it to stipple back over each area to create texture. Let it dry thoroughly.

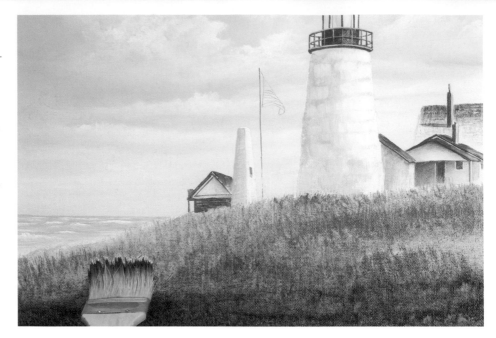

10 Highlight the Grass and Paint the Rocks

Lightly crunch highlights in the lower portion of the grass using brush-mixed Yellow Ochre and brownish green with your no. 2 fan. With the same brush, crunch medium yellow-green into the middle grass. Highlight the top part of the hillside using the same brush with brush-mixed Yellow Ochre and Whiteblend.

Trace the rocks over the grass. Using the no. 4 synthetic flat, add the background rocks with the taupe mixture. Work on only a few rocks at a time—blot the bottoms to blend them into the grass while they're wet. Paint the middleground rocks using the uncleaned no. 4 synthetic flat and brush-mixed taupe and dark brown. Use the dark brown mixture alone for the rocks in the foreground. Add reflected light with the light violet-gray mixture and a no. 0 liner, and add highlights with the marbleized dusty pink mixture using a no. 4 synthetic flat. Blend the wet, inside edges of the reflected light and highlights with a Clearblend-moistened comb.

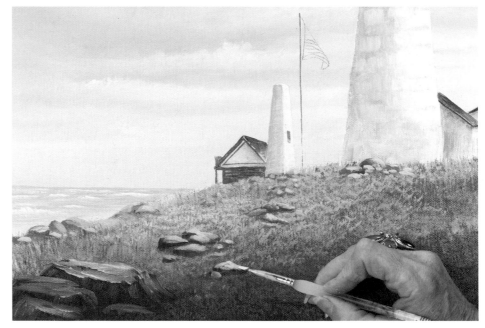

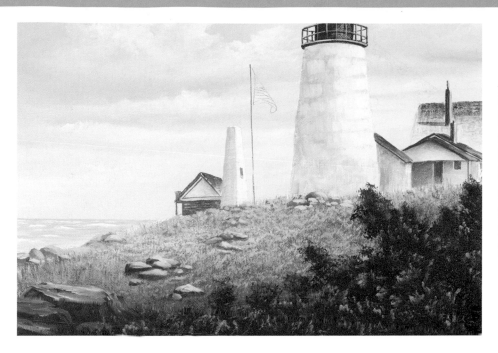

11 Paint the Foreground Foliage

Using your no. 12 bristle flat, stipple Hooker's Green Deep with occasional touches of Burnt Umber and Burnt Sienna onto the foreground foliage. Let it dry, then add the deep teal mixture to the top side of the uncleaned brush and stipple reflected light randomly throughout the foliage.

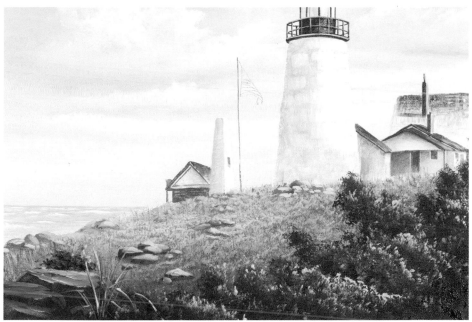

12 Finish the Foliage

Add Vivid Lime Green tinted with Whiteblend to the top of your uncleaned no. 12 bristle flat and stipple highlights onto the tops and right sides of the foliage clusters. Double load your no. 0 liner with Hooker's Green Deep and Vivid Lime Green and add a few individual leaves in a sweeping upward stroke.

13 *Add the Flowers*

Add the Impressionistic flowers to the foliage using the corner of your no. 2 bristle flat. Brush-mix Cadmium Red Medium with Whiteblend and Dioxazine Purple with Whiteblend for the shadowed flowers; use Cadmium Red Medium tinted with more Whiteblend for the brighter blossoms. With a no. 2 round, add some individual leaves along the edges of the foliage using all the colors of the foliage, Hooker's Green Deep, Vivid Lime Green and the deep teal mixture.

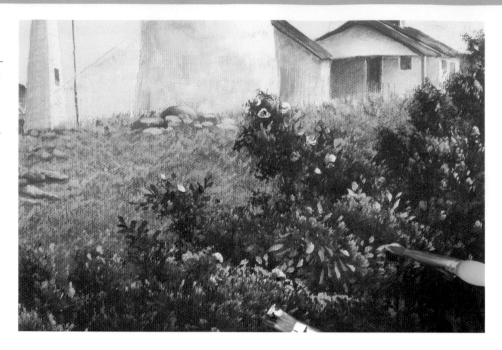

14 *Add the Flag*

Paint the flagpole using your no. 0 liner and the light gray mixture slightly darkened with Payne's Gray. Straighten any wobbles or irregularities on the pole with the chisel edge of a clean, moist ½-inch (12mm) comb. Apply off-white highlights down the right side of the flag pole with the no. 0 liner.

Paint the flag with the no. 0 liner. Use Ultramarine Blue for the top triangle and dry it. Add tiny white dots in the Ultramarine blue area for the stars. Following the curvature of the fabric, paint the stripes using Whiteblend for the white stripes and Cadmium Red Medium for the red stripes.

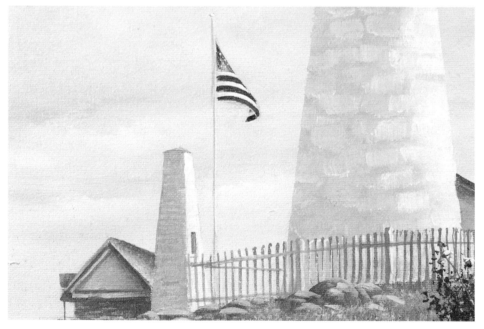

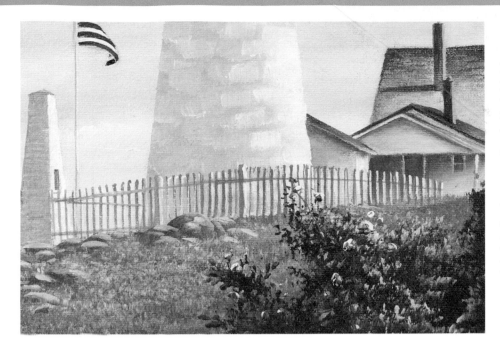

15 *Paint the Fence*

Darken the light gray mixture with Payne's Gray, and use your no. 0 liner in straight downward strokes to create the fence around the lighthouse. (For a fun, different experience, try using a ½-inch [12mm] angular wisp.)

Highlight the right sides of some of the slats using the no. 0 liner and off-white. Once those have dried, use the liner and the dark gray fence color to paint the fence's horizontal supports.

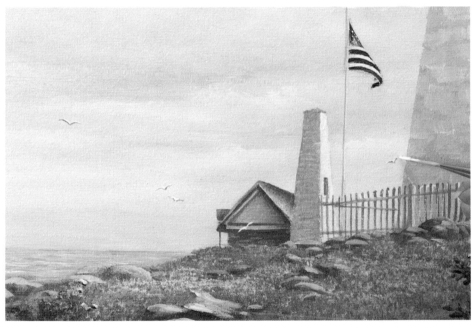

16 *Add the Birds*

Double load your no. 0 liner with brush-mixed light violet-gray, light gray and Slowblend on one side, and drag the other side through White-blend. Hold the brush white-side-up and add a few tiny gulls flying in the distance. With the same brush, use the light gray for their shadows and Whiteblend for their highlight. Sign your painting and enjoy the sight of your *Pemiquid Lighthouse*!

Sierra Falls

There is something about capturing a fleeting moment with your eye, camera or paintbrush that is mesmerizing. Sunrises and sunsets would lose their mystique if they lasted all day, wouldn't they?

Given the time of day in *Sierra Falls*, in conjunction with the swift movement of the eagle, this painting is about capturing a specific, short-lived moment. The sun is rapidly disappearing behind the grandiose mountains as the majestic eagle quickly heads for home. So grab your paints and brushes and let's get moving before this brief, beautiful moment eludes us!

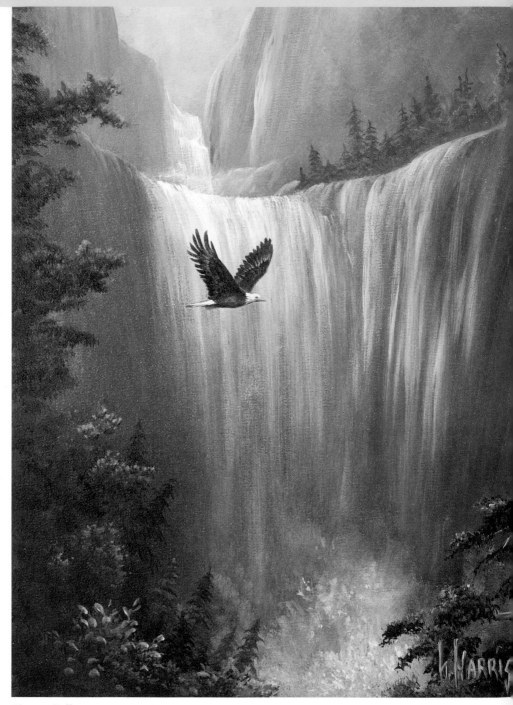

Sierra Falls
12" x 16" (30cm x 41cm)

Materials

Acrylic Colors Burnt Sienna, Burnt Umber, Cadmium Red Medium, Cadmium Yellow Medium, Dioxazine Purple, Hooker's Green Deep, (if you can't find this exact shade, just add black to your Hooker's Green) Payne's Gray, Ultramarine Blue, Vivid Lime Green, Yellow Ochre

Mediums Clearblend, Slowblend (½ teaspoon per cup of water in your water container) Whiteblend

Brushes nos. 6 and 12 bristle flats, no. 0 liner, ½-inch (12mm) comb, no. 2 bristle fan, nos. 2 and 12 rounds, no. 2 bristle filbert, no. 4 synthetic flat, ¾-inch (19mm) mop

Pattern Enlarge the pattern (page 107) 200%

Other palette, large water container, charcoal graphite, stylus, 12" × 16" (30cm × 41cm) stretched canvas, small disposable cups for mediums, paper towels, palette knife, natural sponge, masking tape, acrylic varnish

Color Mixtures

Before you begin, prepare these color mixtures on your palette.

Olive Green	3 Yellow Ochre + 1 Hooker's Green Deep
Charcoal	6 Payne's Gray + 6 Burnt Umber + 1 Dioxazine Purple, 1 Ultramarine Blue + 3 Whiteblend
Dark Green	1 Hooker's Green Deep + 1 Burnt Sienna
Dusty Gray-Green	2 Payne's Gray + 1 Dark Green +2 Whiteblend
Dusty Peach	1 Cadmium Red Medium + 1 Yellow Ochre + 1 Burnt Sienna + 100 Whiteblend
Dusty Violet-Gray	3 Burnt Umber +2 Ultramarine Blue + 1 Dioxazine Purple + 15 Whiteblend
Dusty Lime Green	Dusty Violet Gray + Vivid Lime Green
Leaf Green	2 Vivid Lime Green + 1 Yellow Ochre + 1 Whiteblend
Light Pink	2 of the Medium Pink mixture + 1 Whiteblend
Medium Blue-Violet	3 Ultramarine Blue + 1 Dioxazine Purple + 20 Whiteblend
Medium Pink	2 Cadmium Red Medium + 1 Cadmium Yellow Medium + 50 Whiteblend
Off-White	Whiteblend + 1 Yellow Ochre

1 Prepare the Canvas and Begin the Sky

Trace the image of the mountains onto the canvas, omitting the eagle, trees and foliage. Use a no. 12 bristle flat to paint the top center of the sky and the distant mountains' bases with medium pink, placing occasional dashes of light pink in the uppermost sky. Add dusty violet-gray to the uncleaned brush and continue, making the value darker as you move toward the sides of the canvas. With the same brush, add a touch of charcoal to the wet dusty violet-gray along the right side of the canvas, making the value slightly darker. Blend with the ¾-inch (19mm) mop, starting in the pink area and working outward and cleaning your brush frequently.

2 Block in the Foreground Cliff

Paint the foreground cliff with dusty violet-gray using a no. 12 bristle flat with long, vertical strokes. With the same brush, apply vertical streaks of medium blue-violet through the central portion of the waterfall while the paint is wet. Make the outer portions of the cliff darker by adding vertical streaks of charcoal. Add the highlighted ridges and crevices in the darker areas around the waterfall by randomly adding and blending uneven streaks of light and medium pink and dusty peach into the wet paint using a no. 6 bristle flat. Apply less highlight as you move toward the edges of the canvas. Blend with a no. 2 fan and let the paint dry thoroughly.

3 Paint the Distant Mountains

Trace the distant mountains and waterfalls onto your canvas. Begin the distant mountain peaks on the left with dusty violet-gray and a no. 6 bristle flat, adding faint, random streaks of medium blue-violet into the wet paint with the same brush. Create subtle indications of ridges on the wet mountain with light pink on your ½-inch (12mm) comb. Wipe the excess paint from the comb and use it to blend slightly. Paint the right distant mountain with dusty violet-gray on the no. 6 bristle flat, adding a touch of charcoal to make the right side slightly darker.

Create the ambiance of late evening sunlight by adding light and medium pink highlights, with occasional dashes of dusty peach, on the top and left sides of the mountains' protrusions and boulders using the ½-inch (12mm) comb. Tone the highlight in the brush by adding some dusty violet-gray and apply it on the right sides of the previously highlighted protrusions that receive diffused light, but no direct light. Wipe the excess paint from the comb and blend slightly where the highlight disappears into the crevices on the mountain and boulders.

4 Add the Distant Trees

Stipple tiny dusty gray-green trees along the crest of the cliff on the right using the corner of a no. 4 synthetic detail flat, zigzagging back and forth to create limbs that become slightly larger as they reach the ground. Use your no. 0 liner to tap the treetops in with dusty gray-green. Vary the colors by randomly adding more blue or green to the mixture. Highlight the left sides of some of the trees and lower foliage, pulling them forward, using your no. 2 bristle filbert double loaded with dusty gray-green on bottom and dusty lime green on top.

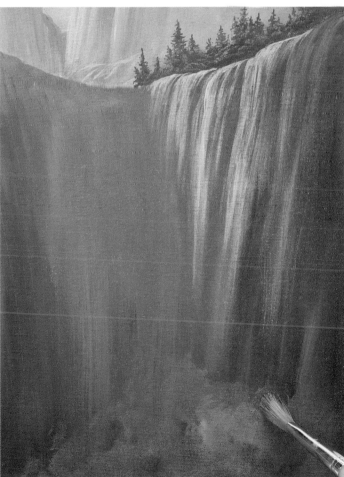

5 Highlight the Cliffs and Begin the Water

Lightly moisten the right-hand cliff with a natural sponge dampened with clean, cool water, then streak Clearblend over the area using a no. 12 bristle flat. Cast late evening sun on cliff's ridges by randomly applying light and medium pink and dusty peach with the ½-inch (12mm) comb, arching the highlights over the crest of the cliff and down the face. Blend with the no. 12 bristle flat moistened with Clearblend, creating gradual transitions between light on the ridges to shadow in the gullies. Add dusty violet-gray and/or charcoal to the highlight colors to dull them gradually as you move toward the outer portions of the cliff, making the evening sun disappear before reaching the edge of the canvas. Dry thoroughly.

Moisten the bottom half of the canvas with the sponge, then apply Clearblend over the area with a no. 12 bristle flat. Add medium blue-violet to your dusty violet-gray mixture and scumble the spray and foam at the base of the waterfall using the same brush.

6 *Paint the Waterfall*

Moisten the waterfall using a ½-inch (12mm) comb and Clearblend, following the flow of the water. With the same brush, apply the medium blue-violet mixture down the waterfall in long, vertical strokes. Apply progressively less medium blue-violet paint as you stroke downward. Load the top of the ½-inch (12mm) comb with off-white and repeat the process, applying streaks of sunlight to the topmost portion of the waterfall. Use more pressure and highlight at the top of each fall and less as you stroke downward, moving from sunlight to shadow. Blend the bottom of the wet paint downward with a no. 2 fan moistened with Clearblend.

Reload your brush frequently. If the paint starts getting sticky let it dry, then apply another layer of Clearblend and start over. Dry the painting.

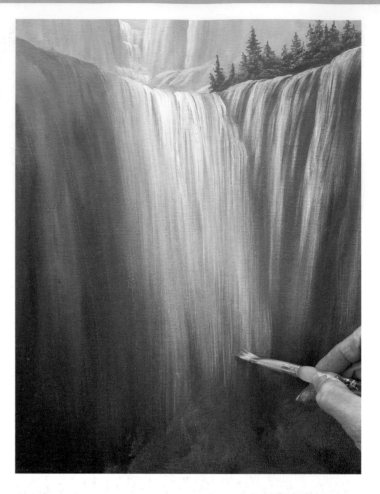

7 *Add the Splashes*

Dampen the foam at the base of the waterfall using your water-moistened sponge. Add Clearblend to the moistened area with a no. 2 fan. Crunch the splashes into the shadowed areas using the no. 2 fan double loaded with medium blue-violet on the bottom and Whiteblend on the top. Scumble to soften the edges of the brighter values of the mist and splashes using a clean, dry no. 6 bristle flat. Let the painting dry thoroughly.

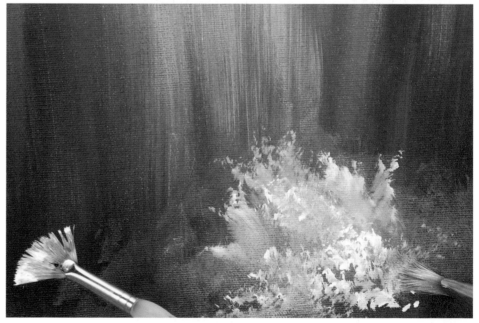

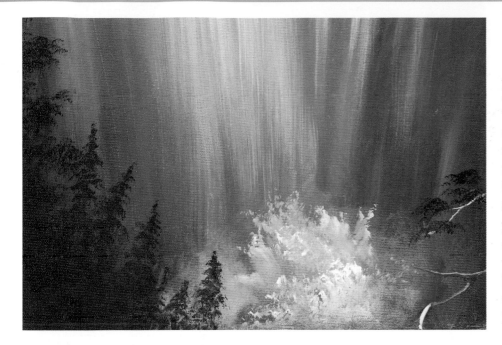

8 Add the Foreground Foliage

Paint the short trees in front of the waterfall with the dark green mixture on your no. 2 filbert. Lightly tap the tip of the brush and zigzag back and forth, creating larger limbs at the bottom of each fir-shaped tree. Stipple the large tree on the left with your no. 6 bristle flat using the same dark green, switching to the filbert when applying delicate tips on the branches. Stipple olive green leaves in the foremost dark green foliage with a light touch of the no. 12 bristle flat.

Draw the limbs on the bottom right of the painting using your no. 0 liner double loaded with charcoal on bottom and dusty peach on top. Using your no. 2 filbert with the dark green, tap and crunch foliage over the limbs.

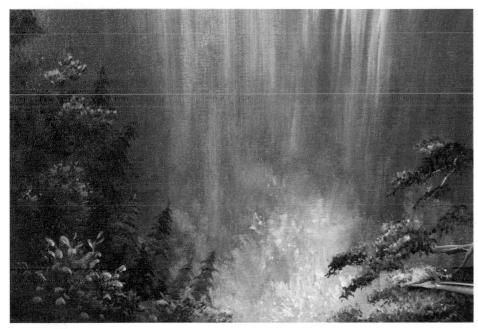

9 Highlight the Foliage

Highlight a few of the small, distant fir trees with a no. 2 filbert double loaded with dark green on bottom and a mixture of dark green and Whiteblend on top, using a light tapping stroke. Double load a no. 12 bristle flat with olive green on bottom and leaf green on top and crunch highlights randomly onto the tips of the bottom left foliage. Stroke a few individual leaves on the top and around this foliage with a no. 12 round double loaded with olive green and leaf green.

Double load your no. 2 filbert with dark green on bottom and leaf green on top and crunch highlights onto the limbs along the left side of the canvas, as well as the foliage on the limbs in the bottom right corner.

10 *Trace and Block In the Eagle*

Trace the eagle over the waterfall. Use your no. 0 liner to paint the wings Burnt Umber. Add a touch of Payne's Gray to the Burnt Umber in your liner and use it to paint the underneath of the forefront wing and stomach, making them slightly darker because they're out of the light.

Brush-mix medium blue-violet and dusty violet-gray and paint shadows underneath the beak, head, neck and tail with your no. 0 liner. Use the same brush to put Whiteblend on the top of the tail and head, blending the bottom edge of the white on the head into the shadow underneath. Block in the beak with Yellow Ochre and a clean liner.

Use your smallest brushes when painting this eagle, and make sure all brushstrokes are in correcct proportion to the feather growth in that area. Paint the feathers by starting the brushstrokes at the exterior tips of each feather and stroke toward where it emerges from the body, wings or tail, conforming to the shape of the body.

11 *Finish the Eagle*

Define one section of the bird at a time to allow for the correct placement of highlights and blending, and dampen each section with Clearblend before adding colors for soft transitions. Brush-mix Burnt Umber with dusty peach using your liner and highlight the stomach and the feathers on the distant wing, blending with a no. 2 round. Add reflected light to the feathers using brush-mixed medium blue-violet and charcoal with your no. 0 liner. Blend with the no. 2 round. Darken this mixture with more charcoal and apply a dot for the eye. Place additional dabs of Whiteblend on the top of the head and back and highlight the top of the beak with brush-mixed Cadmium Yellow and Whiteblend. Create a shadow under the beak and the hint of a foot with Yellow Ochre.

Sign and dry your painting, then spray it with an aerosol acrylic varnish. Savor this moment. Stand back in amazement at your awesome achievement: immortalizing the fleeting moment when the eagle dashes for home … and the sun sets on *Sierra Falls*.

Welcome Home

Welcome Home
16" x 20"
(41cm x 50cm)

Imagine the deep, reassuring contentment of the venturing wayfarer when he rounds the bend and sees his cozy bungalow nestled among the beautiful trees and shrubbery by the curving pathway. Foliage, a brilliant kaleidoscope of magnificent fall colors, blends with the warm glow of the fireplace reflecting in the window, saying to any and all who approach *Welcome Home*.

Materials

Acrylic Colors Acra Magenta, Burnt Sienna, Burnt Umber, Cadmium Red Medium, Cadmium Yellow Medium, Cerulean Blue, Dioxazine Purple, Hooker's Green Deep, Payne's Gray, Ultramarine Blue, Vivid Lime Green, Yellow Ochre

Mediums Clearblend, Slowblend (½ teaspoon per cup of water in your water container), Whiteblend

Brushes 2-inch (5cm) bristle flat, no. 2 bristle fan, no. 0 liner, nos. 2, 6 and 12 bristle flats, no. 2 filbert, ⅜-inch (10mm) angle, nos. 2 and 12 rounds, ½-inch (12mm) comb, no. 4 synthetic flat

Pattern Enlarge the pattern (page 108) 233%

Other 16" x 20" (41cm x 50cm) canvas, palette knife, natural sponge, easel, palette, large water container, black graphite transfer paper, stylus, paper towels, masking tape, plastic container with lid for mixing and storing the basecoat color, small container for the medium

Color Mixtures

Before you begin, prepare these color mixtures on your palette. Remember that autumn colors cover a wide spectrum; vary the value of your mixtures to create new and interesting colors.

Cocoa Brown	2 Raw Sienna + 1 Burnt Sienna + 1 Burnt Umber + Whiteblend
Dark Green	1 Burnt Sienna + l Hooker's Green Deep
Dusty Pink	Whiteblend + a touch of Cadmium Red Medium + a speck of Cerulean Blue
Maroon	2 Burnt Umber + 1 Burnt Sienna + 1 Acra Magenta
Light Maroon	maroon mixture + Whiteblend
Medium Dusty Teal	2 Hooker's Green Deep + 1 Cerulean Blue + 1 Payne's Gray + 3 Whiteblend
Pastel Lime Green	Whiteblend + Vivid Lime Green
Pastel Peach	Whiteblend + a touch of Cadmium Red Medium + a speck of Cadmium Yellow Medium
Pastel Sky Blue	Whiteblend + Cerulean Blue
Dusty Pastel Magenta	pastel sky blue mixture + a touch of Acra Magenta
Dusty Violet	10 dusty pastel magenta mixture + 1 Payne's Gray
Pastel Gray-Green	pastel sky blue mixture + varying amounts of Dark Green mixture
Pastel Yellow-Green	Whiteblend + Vivid Lime Green + Cadmium Yellow Medium
Raw Sienna	2 Yellow Ochre + 1 Burnt Sienna
Red-Orange	1 Cadmium Red Medium + 1 Cadmium Yellow Medium
Bright Orange	2 Cadmium Yellow Medium + red-orange mixture
Tan	2 Burnt Umber + 2 Whiteblend + 1 Payne's Gray

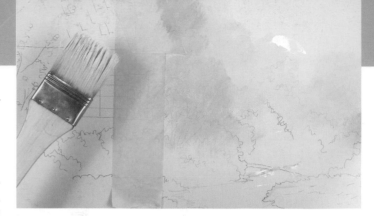

1 Lay in the Sky and Distant Trees

Apply your dusty pink basecoat across the canvas using your 2-inch (5cm) bristle flat, and when it's dry transfer your pattern onto it. Put masking tape vertically along the inside edge of the building and roof so you don't lose the tracing.

Using your 2-inch (5cm) bristle flat, apply the pastel sky blue mixture in long horizontal strokes across the top of the canvas. Use less and less color as you approach the middle. With a no. 12 round, sweep Clearblend across the bottom of the sky to create a gradual value transition. Add a touch of the basecoat mixture to the no. 12 round and apply it over the Clearblend, blending horizontally.

Add dusty pastel magenta to the same brush and smudge and stipple in the distant trees. Darken the color in the brush with a touch of dusty violet and stipple in front of the dusty pastel magenta. Add pastel gray-green to the brush and continue moving toward the foreground. Mix a touch of maroon into the no. 12 round and stipple sparsely onto the right side of the canvas. If your colors become too dark, add a little of the pastel sky blue to lighten the value.

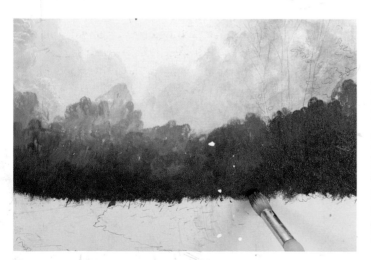

2 Highlight the Distant Foliage and Add Shrubs

Double load the no. 6 flat with pastel gray-green on bottom and pastel lime green on top and tap highlights onto the top and right edges of the tree adjacent to the house. Blot the inside edge of the highlights with your finger. Highlight the dusty pastel magenta foliage with a clean no. 6 flat double loaded with dusty pastel magenta and pastel peach, and blot.

Using a no. 12 round with maroon, establish the foliage behind the path. Randomly brush-mix in a little dusty pink, pastel peach and pastel sky blue to vary the values. Make sure the shrubs are darker at their bases and progressively lighter toward their tops.

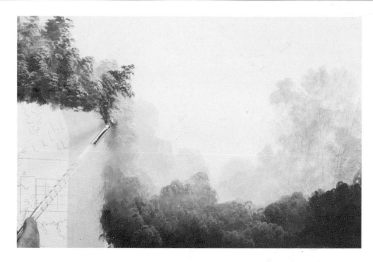

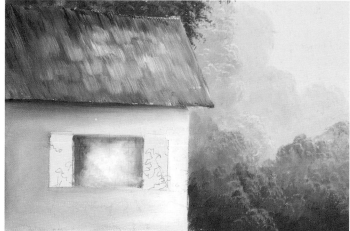

3 Highlight the Shrubs and Add the Trees Behind the House

Load some pastel peach on the top and one side of the uncleaned no. 12 round and stipple highlights on the top right edges of the foliage behind the path. Add red-orange to the pastel peach to create a darker, less vibrant highlight value. Stipple this duller highlight down into the middle and lower portions of the shrubs. Blot the bottom and inside edges of the wet highlight paint with your finger to blend and create a gradual transition in values.

Wipe the excess paint off the no. 12 round and load it with cocoa brown. Begin stippling the tree behind the house, lightening the hue with Whiteblend toward the edges. Vary the tree color by randomly tapping all your warm brown colors—maroon, Raw Sienna, Burnt Sienna and Burnt Umber—into the wet paint with a no. 2 bristle flat. Double load your no. 2 filbert with cocoa brown and pastel yellow-green and highlight the top edges of the tree and the clusters of foliage within the tree. Tone the highlight as you move inward by adding a touch more Yellow Ochre to the pastel yellow-green. Add bright orange to the light yellow side of the brush and stipple toned highlight on some foliage in the middle of the tree.

4 Begin the House

Remove the tape preserving the edge of the house. Brush-mix Payne's Gray and dusty pink into a ⅜-inch (10mm) angle and paint the roof of the building. Make the value slightly darker on the top and left side of the roof and progressively lighter toward the bottom and right with dusty pink. Hold your brush horizontally and use short, choppy strokes following the slope of the roof to create the illusion of shingles. If the brush begins to drag, add a little bit of water. Brush-mix dusty pink and pastel sky blue into the ⅜-inch (10mm) angle to create highlights and reflected light.

Create the light in the window using brush-mixed, marbleized Whiteblend, Cadmium Yellow and Yellow Ochre with your ⅜-inch (10mm) angle. Add red-orange to the same brush as you move toward the edge of the window. Wash out the angle and tap to blend the colors, leaving it with a mottled texture.

Using your ⅜-inch (10mm) angle, streak brush-mixed Payne's Gray and dusty pink down the left side of the house, making it progressively lighter with the dusty pink towards the middle. Rinse your brush and paint the right side of the house with brush-mixed Whiteblend and pastel yellow-green. With a clean, towel-dried angle brush, blend the colors with horizontal strokes.

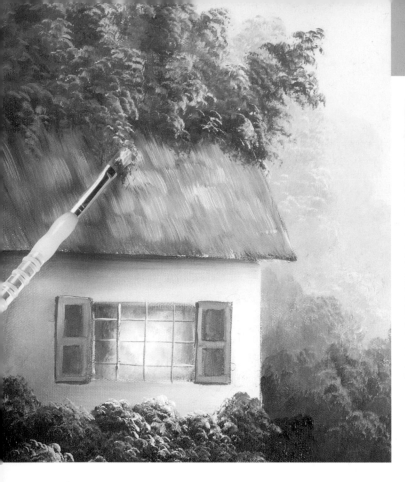

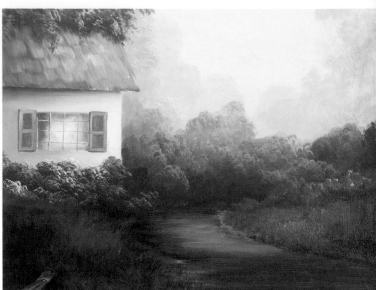

5 Detail the House and Add Foliage in Front of It

When the canvas is thoroughly dried, add the window moldings using your no. 0 liner double loaded with cocoa brown and pastel yellow-green. Using your no. 4 synthetic detail flat, paint the shutters medium dusty teal. With the same brush, highlight the shutters with pastel gray-green and use it to define the shape and the slats. Tidy up the shutters and add shadows using your no. 0 liner and a darker value of the dusty teal.

Stipple in the bushes in front of the windows using your no. 12 round with maroon, adding a touch of Dioxazine Purple at their base. Double load a no. 2 filbert with maroon on bottom and pastel peach on top and tap highlights onto the far left bushes. Clean the brush and double load it with pastel gray-green on bottom and pastel lime green on top; apply highlights to the central bushes. Repeat with red-orange on bottom and bright orange on top for the bushes on the far right. Tap dusty teal reflected light sparsely into the shadow areas.

With a clean no. 2 filbert loaded with cocoa brown, tap the overhanging leaves onto the roof. Double load the no. 2 filbert with cocoa brown and pastel yellow-green and tap in highlights.

6 Block in the Path and Grass

Paint the path using a no. 6 bristle flat and maroon with horizontal strokes. It should overlap slightly into the grass. Paint the middle of the path bright orange using a no. 2 bristle flat. Brush-mix Payne's Gray and Ultramarine Blue into the same brush and add it to the foreground of the path.

Block in the grass by smudging dark green on either side of the path with a no. 12 bristle flat. Blend the edges of the grass into the wet path and shrubs with a dry ½-inch (12mm) comb. While the dark green is still wet, add choppy vertical strokes of brush-mixed Yellow Ochre and Vivid Lime Green to create lighter grass in the central area. Wipe those colors out of the brush and use the same choppy strokes to add maroon to the sides of the canvas and along the path.

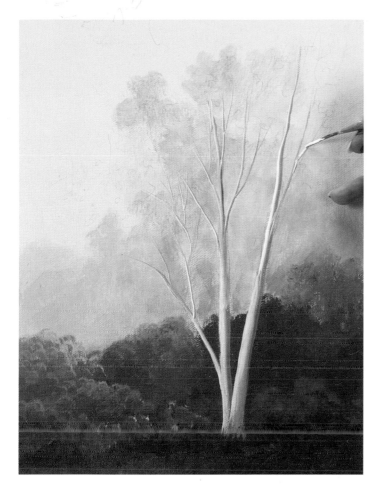

7 Add the Birch Tree

Double load a no. 2 round with tan and Whiteblend and apply the birch tree trunk and limbs on the right side of the painting, placing the Whiteblend on the left side of the trunks. Switch to your no. 0 liner and use the same colors to paint the limbs and twigs. Add the small tree trunks and limbs of the crape myrtle trees in front of the house with the same colors and brush.

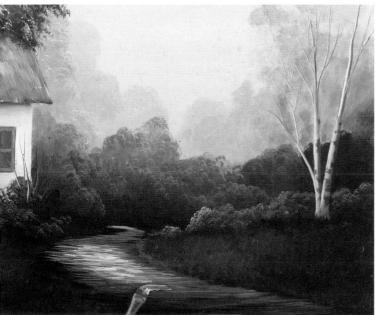

8 Detail the Foliage and Path

Moisten the birch tree trunks with Clearblend using your no. 4 synthetic flat. Add tan and Burnt Umber to the brush and stroke randomly across the wet trees. Blot with your finger to blend.

Double load your no. 2 filbert with cocoa brown and pastel yellow-green and use it to dab highlights onto the left side of the bushes beneath the tree. Add more cocoa brown as you move to the right, into shadow, to make it progressively darker and duller. Use the same colors and brush to highlight the bushes on the left side, but backwards: Place the lighter highlights on the right side and getting duller as they move left, in keeping with the light source.

Moisten the path with clean water using a no. 12 bristle flat, then use the same brush to apply a layer of Clearblend. Using your ½-inch (12mm) comb, randomly place strokes of all the colors of the foliage brush-mixed with a little Whiteblend in the path: red-orange, bright orange, dusty teal, cocoa brown, etc. Clean your comb, then add the pastel yellow-green highlight in the middle.

9 *Add Background Foliage and Leaves to the Birch Tree*

Smudge small translucent patches of foliage over some of the birch tree limbs with gray-green, dusty violet, light maroon, cocoa brown, or any of the pastel foliage colors, individually applied with a no. 6 bristle flat. Smudge or blot the edges of the patches to eliminate hard outer edges. Place clusters of more defined leaves over some patches in the top section of the tree with a light value of brush-mixed bright orange and white double loaded with pastel yellow. Repeat with red-orange and white, double loaded with pastel yellow. Dab pure bright orange and pure red-orange leaves in the lower portion of the tree with a clean no. 2 filbert, applied individually and double loaded.

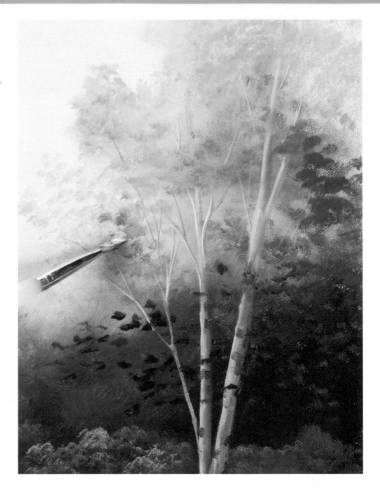

10 *Paint the Birds*

Brush-mix tan and Slowblend into your no. 0 liner and double load it with Whiteblend. Paint the tiny birds flying in the central area of the canvas.

11 *Paint the Crape Myrtle Blossoms*

Add the blooms on the crape myrtle trunks and twigs in front of the house with a no. 2 filbert double loaded with Acra Magenta and pastel peach.

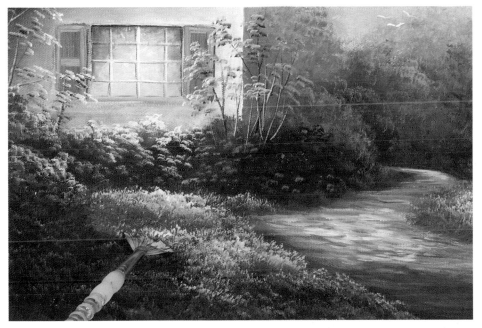

12 *Highlight the Foreground Grass*

Lightly crunch reflected light, highlights and flowers into the grass with a no. 2 fan. Blot the bottom of the wet paint occasionally to create a gradual blend. Use medium dusty teal on the no. 2 fan for the reflected light in the grass. Double load the fan with maroon on bottom and red-orange on top for the patches of flowers in the foreground. Wash the fan and double load it with dark green on bottom and pastel lime green on top to highlight the grass. Add pastel yellow-green to the lime green side of the brush and crunch brighter highlights into the previously highlighted area.

Add fallen leaves on the grass around the birch trees using bright orange and then red-orange on the no. 2 filbert, blotting to anchor some of these to the grass. Sign, dry and then spray your painting with a clear aerosol acrylic varnish. *Welcome Home* your masterpiece by selecting a perfect frame to complement its inviting colors.

Timeless Reflections

Have you ever been walking in the park just as day slipped into darkness? There is a magical moment when the streetlights flicker on and spill their warming beams over the surrounding flowers, foliage and meandering stream. If you're like me, you seek to savor the beauty of those moments for a lifetime. This project will show you how easy it is to record this magical memory on your canvas.

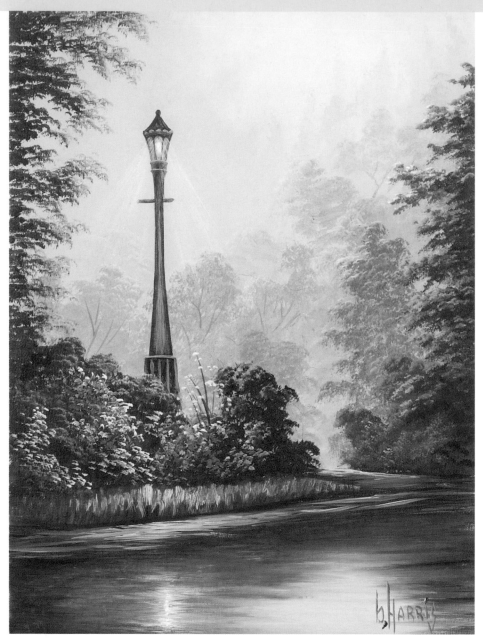

Timeless Reflections
20" x 16" (51cm x 41cm)

Materials

Acrylic Colors Burnt Sienna, Burnt Umber, Cadmium Red Medium, Cadmium Yellow Medium, Ceramcoat Lavender Lace (or Whiteblend + Payne's Gray + Dioxazine Purple + Ultramarine Blue mixed to a light gray), Dioxazine Purple, Hooker's Green Deep (or add black to Hooker's Green), Payne's Gray, Ultramarine Blue, Vivid Lime Green (Thalo Yellow Green), Yellow Ochre

Mediums Clearblend, Slowblend (½ teaspoon per every cup of water in your water container), Whiteblend

Brushes no. 2 bristle fan, ¾-inch (19mm) mop, nos. 2, 6 and 12 bristle flats, 2-inch (5cm) bristle flat, no. 0 liner, ½-inch (12mm) comb, no. 4 synthetic flat

Pattern Enlarge the pattern (page 109) 154%

Other large water container, stylus, 16" × 20" (41cm x 51cm) primed and stretched canvas, 16" × 20" (41cm x 51cm) precut mat template with 2" (5cm) borders, permanent gold marker (Krylon 18kt Gold Leafing pen is used here; available in most arts and crafts stores), wide shipping or masking tape, scissors, palette knife, natural sponge, acrylic varnish, small container for the medium

Color Mixtures

Before you begin, prepare these color mixtures on your palette.

Light Gray	Whiteblend + Payne's Gray + Dioxazine Purple + Ultramarine Blue (or use Ceramcoat Lavender Lace)
Tan	light gray mixure + a speck of Burnt Umber + Payne's Gray
Taupe	light gray mixture + a touch of Burnt Umber
Mocha	taupe + Burnt Umber + Burnt Sienna
Light Violet-Gray	light gray mixture + a bit more Dioxazine Purple and Burnt Sienna
Light Gray-Green	light violet-gray mixture + a speck of Burnt Umber + Hooker's Green Deep
Light Lime Green	Whiteblend + Vivid Lime Green
Light Peach	Whiteblend + a touch each of Cadmium Red Medium + Cadmium Yellow Medium
Light Pink	Whiteblend + Cadmium Red Medium + a speck of Cadmium Yellow Medium
Off-White	Whiteblend + a touch of Yellow Ochre

1 Add the Basecoat and Mat Border

Use your 2-inch (5cm) bristle flat to apply a basecoat of light gray. Trace the inside of the mat with a gold permanent marker.

Remove the mat and cover the border with masking or shipping tape, overlapping the gold lines on all four sides. Press down firmly so no paint can get underneath it.

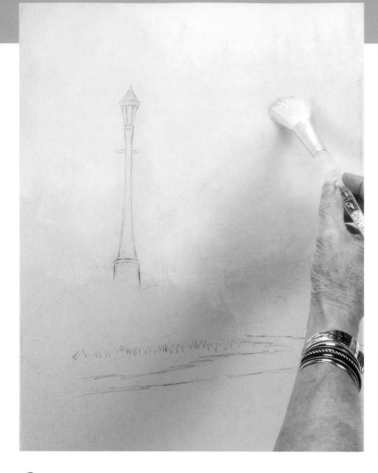

2 *Paint the Sky and Begin the Distant Trees*

Trace the pattern onto your canvas. Apply light pink across the top right area of the sky in short, choppy strokes with a no. 12 bristle flat. Add light gray incrementally to the uncleaned brush, along with an occasional touch of Whiteblend, and continue painting the sky with slight, random variations in value. Blend with a ¾-inch (19mm) mop to create a soft transition. Using the corner of a no. 2 bristle flat and brush-mixed light pink and light gray, lightly tap distant treetops overlapping the bottom of the light pink sky. Blend the bottom of the trees where they merge into the background by tapping with your no. 12 bristle flat. Add brush-mixed light gray, a touch of Whiteblend and Clearblend and scrub around that area if necessary to create a gradual transition from the trees to the background color. Soften brush marks with the ¾-inch (19mm) mop.

3 *Add Middle Ground Trees*

Stipple trees into the middle ground with a no. 2 bristle flat, making them progressively darker as you come toward the foreground. Begin with a light violet-gray tree top on the right side of the canvas, just below the distant trees. Add light pink to the top of the no. 2 bristle flat and lightly tap highlights onto the top left sides of the tree. Alternate adding incremental amounts of mocha, taupe and tan to your brush and stipple rows of tree tops throughout the middle ground, making the trees varied in color and each row slightly darker as they come to the forefront. Add light pink to the top of the uncleaned brush to highlight each tree color as you progress. Add light gray to the uncleaned brush when stippling in the lower portions of these foremost middle trees, making the bottom area of the trees color pastel (almost pure light-gray), especially in the opening above the path. Add thin tree trunks and limbs underneath the tops and within the leaves using the tan mixture and your no. 0 liner. Blot the bottoms of the tree trunks with your finger to sink them into the foliage.

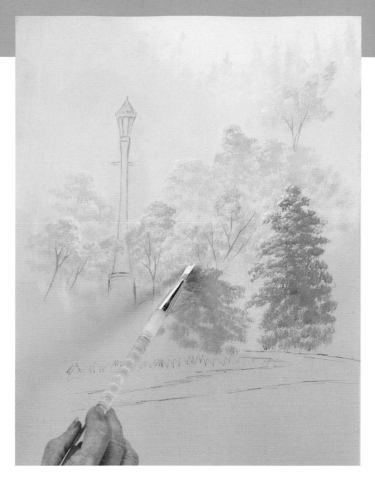

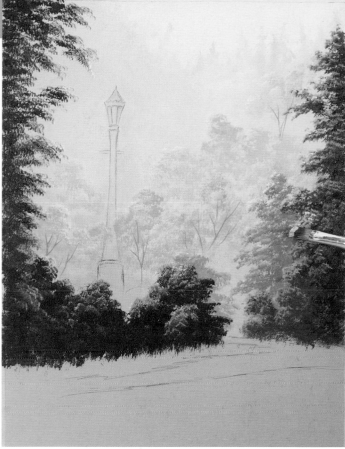

4 Define the Trees

Stipple the tree on the left side of the path with your no. 6 bristle flat and light gray-green. Add off-white to one side of the uncleaned brush and use one corner to lightly tap highlights along the top left sides of the tree top. Brush-mix Hooker's Green Deep and Burnt Umber into the light gray-green and apply a slightly darker tree on the right side of the path, applying and highlighting it in the same way as the first tree.

5 Add the Foreground Foliage

Add a touch each of Hooker's Green Deep and Burnt Umber to the no. 6 bristle flat and stipple the short shrub on the left side of the path. Highlight the top left sides of this shrub's clusters with the same brush double loaded with a mixture of light lime green and light gray. Use a clean no. 6 bristle flat to stipple shrubs around the lamppost and the tall tree on the left with brush-mixed Hooker's Green Deep, Payne's Gray and Burnt Umber. Highlight these shrubs and tree by frequently double loading the uncleaned no. 6 flat with light lime green and turning the brush to make the highlights face the lantern.

Stipple the rusty brown tree on the right using a clean no. 6 bristle flat and brush-mixed mocha, Burnt Sienna and/or Burnt Umber, with an occasional touch of Cadmium Red Medium. For the darker portions along the ground, add Burnt Umber and a touch of Payne's Gray to your brush. Blot to merge the tree and shrub. Double load the same brush with light peach and dab highlights along the top left sides of the branches and leaf clusters, applying a lot of highlighted leaves on the outside tops of the branches, a few in the middle and not many in the shadowy areas. Add a few light pink highlights on the far left tips of some branches.

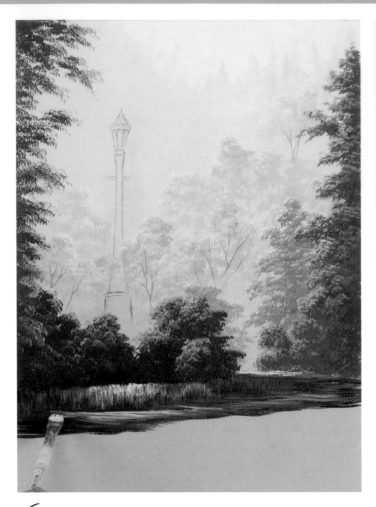

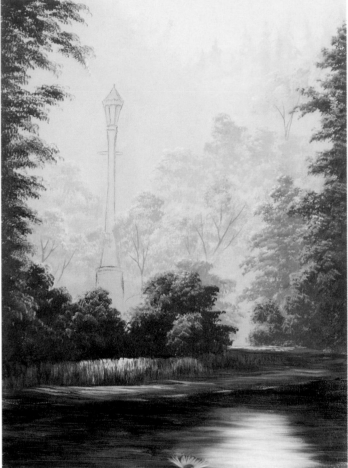

6 Add the Grass and Path

Paint the grass using vertical strokes of the no. 2 fan brush and Hooker's Green Deep thinned with water. With the same brush, add shadows at the base of the grass using short, horizontal strokes of diluted Payne's Gray. Highlight the grass with brush-mixed Hooker's Green and Vivid Lime Green using a no. 2 fan. Incrementally add light lime green and off-white to the brush for progressively lighter values centrally located beneath the light.

Paint the path with Burnt Umber using horizontal strokes of the ½-inch (12mm) comb. Add little streaks of Dioxazine Purple and Payne's Gray in the shadowed areas. Highlight the wet path paint with the same brush using light peach, adding extra illumination with pink in front of the lightest grass.

7 Paint the Water

Slightly moisten the water area with a sponge, then add Clearblend with a no. 12 bristle flat. Quickly add and blend the water's reflected colors into the wet Clearblend using horizontal strokes, beginning with the lightest and ending with the darkest. Apply light pink in the lower part of the water with your no. 6 bristle flat. Around this, working outward with the same brush, add the base color and then light gray-green, with occasional dashes of mocha. Paint the remaining area with brush-mixed Hooker's Green Deep, Burnt Sienna and Burnt Umber with the no. 12 bristle flat. Blend the colors together slightly with a no. 2 bristle fan, holding and stroking your brush horizontally and lightly. Keep the colors from becoming muddy by wiping your brush clean on a paper towel between almost every stroke. Do not blend excessively. Leave strong contrast between the light and dark colors, with faint streaks of the medium and light colors crossing into the outer edges of the dark color and vice versa. Dry it thoroughly.

8 Paint the Lamp Light and Post

With your no. 0 liner, apply brush-mixed Cadmium Red Medium and Cadmium Yellow Medium to the top, bottom and side edges of the light. Place a bright yellow mixture of Cadmium Yellow Medium and Whiteblend in the center, then tap to blend, leaving a mottled appearance. Indicate a flame in the center of the light with a dab of off-white using the tip of your liner. Let it dry.

Using a no. 0 liner, paint the metal of the lantern and lamppost with Payne's Gray. Use the no. 4 synthetic detail flat for the larger parts of the post. Blot the Payne's Gray with your finger at the bottom of the lamppost where it disappears into the foliage.

9 Highlight the Lamppost

Working wet-into-wet a section at a time, cover the lantern with Clearblend and highlight it with light gray using your no. 0 liner. Soften the edges with a no. 4 synthetic flat moistened with Clearblend. Continue while wet and apply a soft line of the peach mixture down the center of the lamppost with your liner, blending both sides of the peach with the Clearblend-moistened no. 4 synthetic flat.

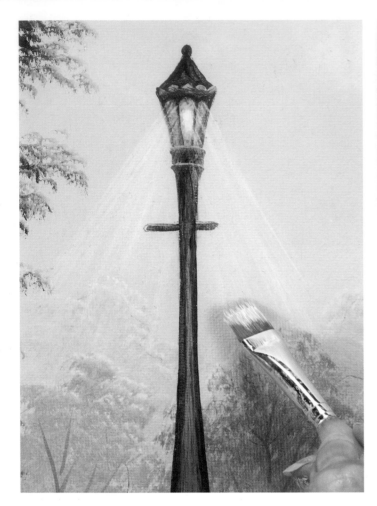

10 *Add Light Rays*

With a clean, moist ½-inch (12mm) comb, paint streaks radiating downward from the lantern. Make each stroke perfectly straight and each subsequent stroke at a slightly exaggerated angle so as to fan outward at the bottom. Brush-mix one part off-white with two parts Clearblend into the comb and apply the light rays over the moistened areas. Keep all your brushstrokes perfectly straight, but fanning outward. Do not allow the strokes to bend: Should you get a bend in one, immediately rinse your comb and correct the area with Clearblend.

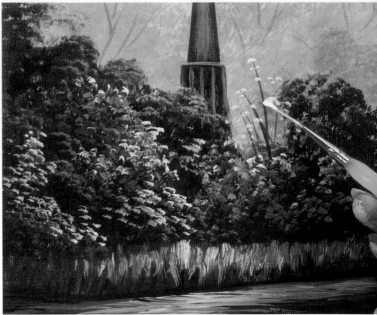

11 *Add the Flowers*

Stipple clusters of flowers underneath the lamppost with a marbleized brush-mixture of Dioxazine Purple and Whiteblend, adding progressively more Whiteblend in the top portions. Lightly blot the bottom of each cluster while wet to sink the blooms into the foliage. Repeat with Ultramarine Blue mixed with Whiteblend and Cadmium Red Medium mixed with Whiteblend. Use the same technique to create additional flower colors by mixing any of the previous colors together or add any color flower you choose to suit yourself. Apply duller flowers on the right of the path by graying each respective flower with a touch of light violet-gray.

Using your liner brush and diluted Hooker's Green Deep, swish upwards with the tip of your liner to create various lengths of stems springing from the shrubbery to the right of the lamppost. Brush-mix Cadmium Yellow Medium, Yellow Ochre and a touch of Whiteblend into the liner then double load it with off-white. With the off-white side of the brush turned toward the light, dab yellow flowers randomly across the stems.

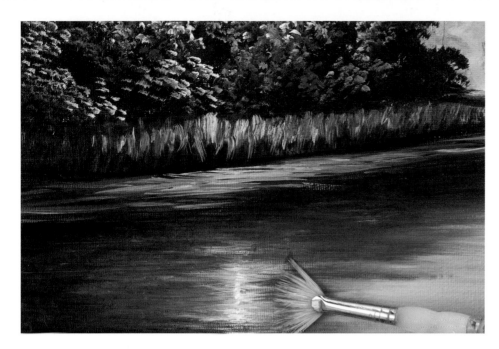

12 Detail the Water

Moisten the water with brush-mixed Clearblend, water and Slowblend using a no. 12 bristle flat. Lightly stipple some of the flowers' reflections into the water using the corner of a no. 2 bristle flat. Shimmer and ripple the reflections by first making short, vertical strokes over the wet colors with your no. 2 fan, then making slightly longer horizontal strokes.

Add the lamplight's reflection using a ½-inch (12mm) comb turned vertically; stipple Cadmium Yellow Medium and off-white into the water directly beneath it. With a clean no. 2 fan moistened with Clearblend, pull some of the outer edges of the stippled lamplight colors horizontally across the water to soften and blend.

13 Remove the Tape and Enjoy

Remove the tape—if the gold lifts with it, touch up the lines using the template again or a yardstick. Sign and dry your painting, then spray it with a clear acrylic aerosol varnish and enjoy your *Timeless Reflections*.

Conclusion

Happy, creative thoughts help keep us mentally and physically healthy. I have never met an artist who did not say they were infinitely happier since developing their artistic talents.

Learning to paint for many is an elusive thing. Unless they are lucky enough to see art teaching programs on television, some people would never have the opportunity to learn. Many viewers never pick up a brush, but paint along in their minds. For them, the mental exercise satisfies the creativity in their hearts and souls. For others, those who want to physically put a brush to the canvas, some have no other way to take art classes besides television. Viewing these programs is like having a private teacher in your home. Art teaching television programs bring great joy to all who watch. Contact your local PBS and cable networks and encourage them to include more art teaching programs in their schedule.

Hopefully you have had the opportunity to view my art teaching television programs. If so, contact your station and thank them for airing the shows. If you have not seen them, request them by name: *Painting With Brenda Harris*. I have filmed many series that are available to your stations.

Get involved with helping others learn to paint. The more you give the more you get. If you share with others how you paint, as I am sharing with you, your talents will multiply rapidly. It's life's reward for sharing! So, reward yourself and others—share!

I hope you have had fun painting these compositions and have learned many useful landscape painting techniques that will help you be successful in your art hobby or career, whichever your goal. I wish you great success. May this book motivate you to express the artistic beauty that lies within you.

Sincerely, your painting pal,
Brenda Harris

Welcome Home
12" x 16" (30cm x 41cm)

Lazy River
14" × 18" (35cm × 45cm)

Patterns

Riding the Wind
Enlarge this pattern 117 percent

Palm Trees in Paradise
Enlarge this pattern 200 percent

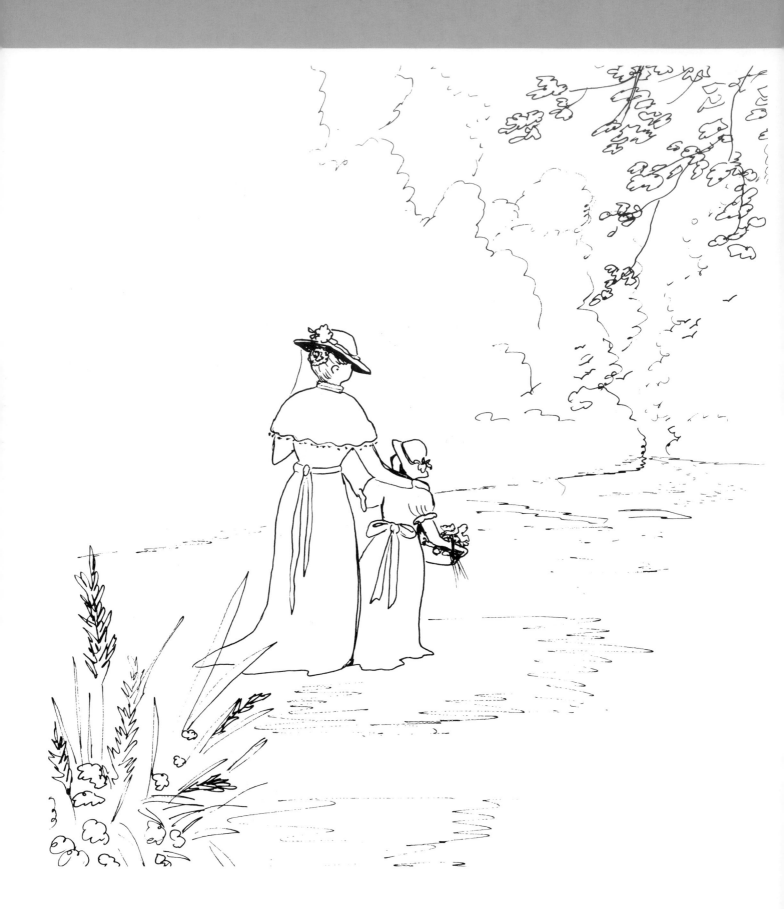

Out for a Stroll
Enlarge this pattern 182 percent

Stone Ground
Enlarge this pattern 192 percent

Pemaquid Lighthouse
Enlarge this pattern 182 percent

Sierra Falls
Enlarge this pattern 200 percent

Welcome Home
Enlarge this pattern 233 percent

Timeless Reflections

Enlarge this pattern 154 percent

Index

Learn to paint like the pros with these other fine North Light Books!

Beloved TV painter Brenda Harris brings all the charm and approachability of her PBS show directly to you with this easy to follow instructional guide. Thirteen step-by-step projects will have you painting heartwarming scenes ranging from landscapes and barns to flowers and birds. With templates that help you easily transfer every project to your canvas, *Painting with Brenda Harris* will have you creating fast and fun acrylic scenes in no time!

ISBN-13: 978-1-58180-659-5
ISBN-10: 1-58180-659-0
Paperback, 112 pages, #33254

In the second installment of her series, well-known TV painter Brenda Harris presents 13 new fast, easy and fun acrylic projects. Brenda guides you through each *Precious Time* step by step, from the first brushstroke down to the last charming detail. With her explanations of all the basic techniques and and dozens of useful tips, as well as patterns for each project, you'll create a lovely painting you can be proud of in just a few hours!

ISBN-13: 978-1-58180-698-4
ISBN-10: 1-58180-698-1
Paperback, 112 pages, #33357

Lee Hammond brings twenty years of professional experience directly to you in this easy to follow guide to acrylic painting. Paint along with Lee as she takes you through twenty-five step-by-step demonstrations on such favorite subjects as still lifes, landscapes, people, flowers and animals. Pick up this friendly and fun acrylics manual and start painting today!

ISBN-13: 978-1-58180-709-7
ISBN-10: 1-58180-709-0
Paperback, 112 pages, #33375

Start painting your friends and family today with this easy, fun guide to capturing people in watercolor! Get near-instant results with the lesson on materials, a glossary and more than 20 demonstrations that will teach you everything you need to know.

ISBN-13: 978-1-58180-719-6
ISBN-10: 1-58180-719-8
Paperback, 112 pages, #33392

These books and other fine North Light titles are available at your local fine art retailer, bookstore or online supplier.